Ivories of the West

Massimo Carrà

HAMLYN

Translated by Raymond Rudorff from the Italian original

Gli avori in occidente

© *1966 Fratelli Fabbri Editori, Milan*

This edition © *1970*
THE HAMLYN PUBLISHING GROUP LIMITED
LONDON · NEW YORK · SYDNEY · TORONTO
Hamlyn House, Feltham, Middlesex, England

SBN 600348024

Text filmset by Filmtype Services, Scarborough, England

Printed in Italy by Fratelli Fabbri Editori, Milan

Bound in Scotland by Hunter and Foulis Ltd., Edinburgh

Contents

PREHISTORY AND EARLY CULTURES

Old Stone Age man lived in a world that was total: he made no distinction between finite and infinite, real and imaginary. There were frightening and incomprehensible phenomena everywhere, which appeared to demonstrate the omnipresence of superior powers. Reality could be known and dominated only by means of a magical or ritual process of annexation: a process in which the origins of art are to be found.

Even in the Aurignacio-Perigordian period, about 20,000 BC, *homo sapiens* was making artefacts with all the qualities requisite to works of art. Ivory was already being carved into precise, premeditated shapes. It was a fine, hard ivory taken from the mammoths that roamed over most of Europe, and could be used for such delicate work as the representation of the female head at St Germain-en-Laye (plate 1).

Examples have been discovered throughout Europe,

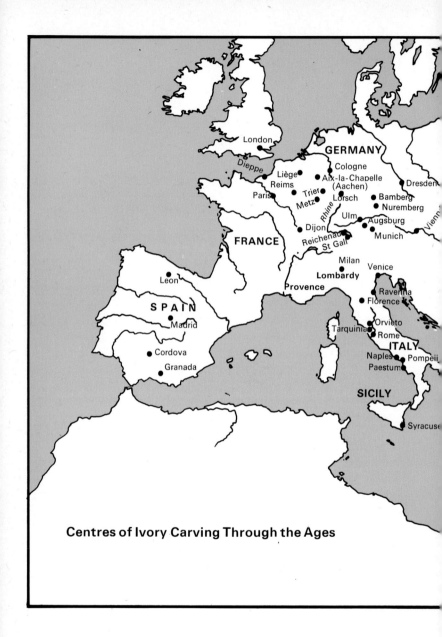

Centres of Ivory Carving Through the Ages

London
Dieppe
Liège
Reims
Paris
Trier
Metz
GERMANY
Cologne
Aix-la-Chapelle
(Aachen)
Lorsch
Dresden
Bamberg
Nuremberg
Rhine
Dijon
Ulm
Augsburg
Reichenau
St Gall
Munich
FRANCE
Milan
Lombardy
Venice
Provence
Ravenna
Florence
Leon
SPAIN
Madrid
Orvieto
Tarquinia
Rome
ITALY
Cordova
Naples
Pompeii
Granada
Paestum
SICILY
Syracuse
Vienna

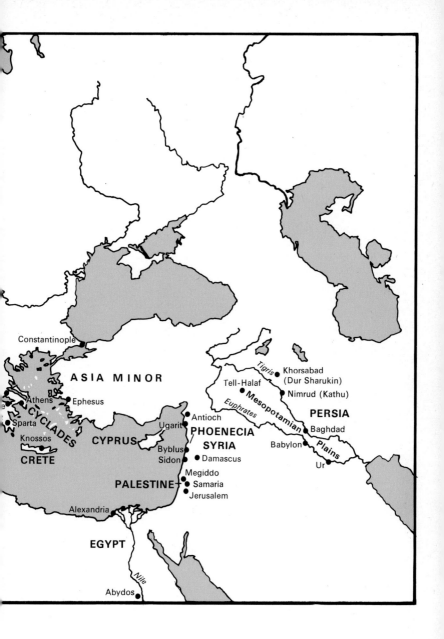

Constantinople

ASIA MINOR

Athens
Ephesus

CYCLADES
Sparta
Knossos
CRETE

CYPRUS

Tigris
Khorsabad
(Dur Sharukin)
Tell-Halaf
Nimrud (Kathu)

Euphrates
Mesopotamian
PERSIA

Antioch
Ugarit
PHOENECIA
SYRIA
Byblus
Sidon
Damascus

Baghdad
Babylon
Plains
Ur

Megiddo
PALESTINE
Samaria
Jerusalem

Alexandria

EGYPT

Nile
Abydos

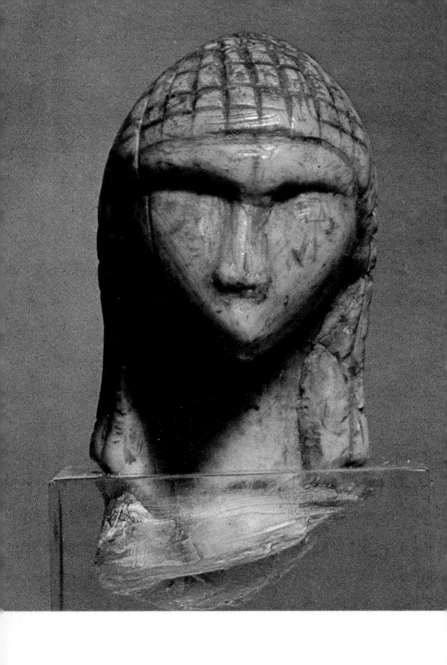

1 Palaeolithic art, Aurignacio-Perigordian period. *Female head*. Musée des Antiquités Nationales, St Germain-en-Laye. This head was found in the Grotte du Pape at Brassempouy in the Périgord region, and is one of the most beautiful prehistoric pieces of ivory. The carving of the features and the hair displays considerable expressive skill.

2 Palaeolithic art, Aurignacio-Perigordian period. *Venus of Brassempouy*. Musée des Antiquités Nationales, St Germain-en-Laye. Among the most important prehistoric ivories are the figurines known as steatopygous Venuses, which were inspired by female fecundity. The exaggeration of those parts of the body connected with child-birth and child rearing is such that these figures often approach abstraction.

3 Palaeolithic art, Magdalenian period. *Horse*. Musée des Antiquités Nationales, St Germain-en-Laye. In about the 20th millennium BC, ivory sculptors began to make animal figures. The work reproduced is one of the most important because of its fine modelling and accurate observation of reality.

4 Egyptian art. *Knife handle from Djebel-el-Arak*. Musée du Louvre, Paris. A wonderful example of Egyptian ivory carving of the 3rd millenium BC. The restricted space has been skilfully filled with a swarm of human and animal figures in a kind of arabesque of light and shade forming a kind of frieze.

1 Palaeolithic art, Aurignacio-Perigordian period. *Female head*. Musée des Antiquités Nationales, St Germain-en-Laye.

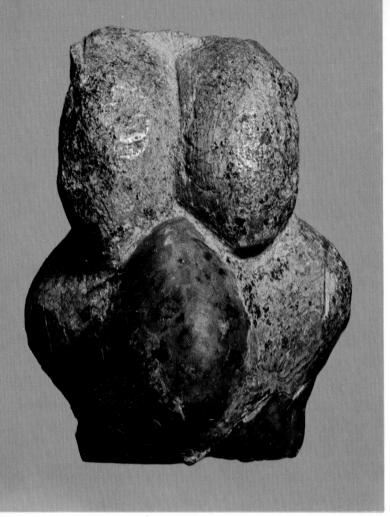

2 Palaeolithic art, Aurignacio-Perigordian period. *Venus of Brassempouy*. Musée des Antiquités Nationales, St Germain-en-Laye.

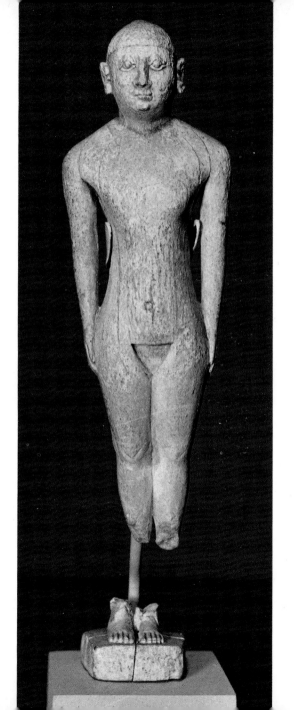

21

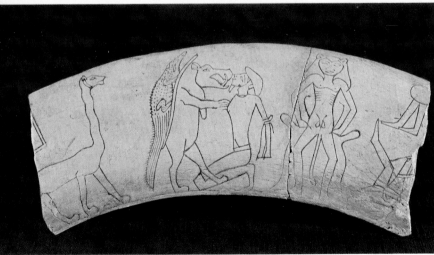

8 Egyptian art. *Ivory fragments with magical scenes.* Musée du Louvre, Paris.

The finest example of Egyptian ivory carving is perhaps the Djebel-el-Arak knife handle in the Louvre (plate 4), which dates from about the 3rd millennium BC. It is covered with a swarm of little figures carved with elegance and vigour; men and beasts are assembled in animated scenes of hunting and fighting in which full and empty spaces, light and shade are combined in a skilfully balanced, linear and spatial composition. It is a key work because of its complex composition and figurative rendering, and is a work of art in its own right rather than a mere example of craftsmanship or a document of its time.

As the structure of Egyptian civilisation developed and the power of the Pharaohs grew, a gulf developed between the major and the minor arts. Ivory carving tended to become the province of the jeweller, while sculptures grew in size and were made with other materials such as limestone, wood, diorite, and black or pink granite. The major arts became dominated by the figure of the Pharaoh as repository and guardian of the divine spirit; art became detached, solemn, abstracted from this world – a unique combination of the stylised and the observed. The minor arts, and

ivory statuettes in particular, display a far greater awareness of the world of man, their feelings and their everyday roles. A good example is the statuette of a young girl, found at Taza and now in the Berlin Museum.

Egyptian civilisation never lost its own independent character, despite exchanges and contacts with other cultures. The Sumerians, the Akkadians, the Babylonians, Persians and Phoenicians possessed cultures as active and creative as that of Egypt, but much less homogeneous: they were produced by peoples whose political greatness alternated with long periods under the suzerainty of others, and who were constantly influenced and attracted by Egyptian art.

After settling in the fertile plains of Mesopotamia in the 3rd millennium BC, the Sumerians created a complex civilisation which was distinguished by an intense religious feeling and a pantheon of gods, most of whom personified natural forces. Art was essentially devoted to this side of life, and consequently reflected the tensions and preoccupations of a rather severe civilisation. Myth and magic, the sacred and fantastic, leavened the creative imagination of Sumerian sculp-

tors, whether they worked in stone, wood, clay, or (less frequently) ivory. Their rich, splendid objects found at Ur display an extraordinary 'magic realism' which confers personality and autonomy on the work of art through images and suggestions totally extraneous to ordinary life.

A similar impulse lay behind most of the works produced by the civilisations of the Near East – Assyrian, Babylonian and even Persian. In these, ivory objects were more widely produced. Outstanding examples are the reliefs with wild animals attacking a goat (Louvre, Paris), the head from the temple of Nebo, dating from the epoch of Sargon II (Oriental Institute Museum, Chicago), and the gilded ivory, ornamented with cornelian and lapis lazuli inlays, found at Nimrud in Assyria (8th century BC). Some experts consider this last piece to be of Phoenician origin, and this might well be the case, since the Phoenicians, a great race of merchants and adventurers, travelled widely and absorbed many foreign elements into their own culture. Phoenician art was a curious medly of elements taken from all the great civilisations of Asia Minor and Africa. The numerous ivories – mostly

bas-reliefs – found at Nimrud and Tell-Halaf are distinguished less by expressive originality, a quality rarely present in Phoenician art, than by technical excellence. Their carvers proved able to take over alien forms and re-elaborate them in a kind of mannerist style which shows clear influences from Mesopotamia, Persia and even India, as well as strong Egyptian influence. The Phoenicians transmitted these influences to southern Europe and Greece by way of Crete, and even to Italy by way of Etruscan art. Their art was often rather undistinguished, but it was of considerable historical importance.

GREECE AND ROME

In the part of the world affected by Hellenic culture, ivory work was best and most abundant in the early period. Here, too, purposes were religious. One of the finest examples of this art came from Crete, which was to some extent the Mediterranean precursor of Greek culture, and provided a point of meeting for the cultures of Egypt and Asia Minor. This work was the

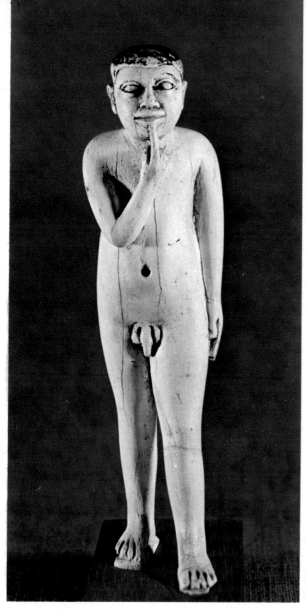

9 Sumerian art. *Statuette of a man*. Musée du Louvre, Paris.

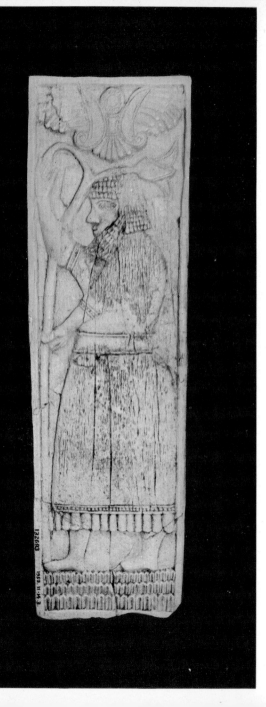

from Russia to the Atlantic, but the most interesting are those found in southern France. Even in these early objects, ivory was used for a triple purpose: magical-religious, utilitarian, and ornamental.

From this time, the art of using such a subtle yet hard, precious yet delicately 'tonal' material to give expression to intellectual, religious or aesthetic concepts is found in every age and every culture: in India as in China, in America as in Europe. In the area around the Mediterranean, where artists developed a definite concept of man and his significance, the evolution of ivory art was rich and complex – and quite different from that of eastern Asia.

It is significant that the human figure was one of the first subjects to be treated, as though the development of art corresponded to man's confused instinct to question himself. The magical and propitiatory element was strong, and in particular woman is shown almost exclusively as a being endowed with the mysterious power of perpetuating the species. Female figures are rendered with varying degrees of distortion of belly, buttocks, thighs, etc., on the many figurines that have been discovered. These steatopygous

4 Egyptian art. *Knife handle from Djebel-el-Arak*. Musée du Louvre, Paris.

Venuses are often highly stylised and geometrical in design. Representational subjects appeared on objects made for warfare or hunting—for example, animal figures, which were thus 'captured' by the Neolithic artist, who hoped to influence the outcome of the real hunt in his own favour.

In historic times ivory art became far more important, widespread and defined. Elephants' teeth were used as commercial objects in cultural centres from the earliest times; but it was in the eastern part of the Mediterranean, where civilisation developed most rapidly, that ivory was first used as an object of luxury. It was there that ivory and gold were considered as the most suitable materials for decorating the temples of the gods or underlining the importance, value and style of objects.

The art quickly began to flourish in Egypt. Ivory was obtained from the teeth of hippopotami, which were found in large numbers in the Nile, and local craftsmen soon became adept at carving it into combs, hair-pins, bracelets, trinkets and votive, magic or religious objects.

As early as the pre-dynastic period, before metals

were used, the first signs of developing civilisation appeared in the company of an intense spiritual life. To the Egyptian, the world consisted of superimposed terrestrial, sub-terrestrial and heavenly planes: the first for the living, the second for the dead, and the third for genii, demiurges and divinities. This concept gave rise to a profound sense of life and time, and above all to a belief that life continued after death. It is to this belief that we owe the preservation of so many objects dating from a very early period. The tombs of the dead were furnished with everything the deceased might need in his future life: among these were the countless ivory female figurines that have been found; charming examples of these 'concubines of death' may be seen in the Louvre (plate 5). The earliest examples date from the 5th millennium BC. They are small works of great inventive power in which realistic observation is combined with a lucid sense of the supernatural. These qualities are also exemplified by the mutilated and enigmatic statuette of a Pharaoh of the Thinis period, found during excavations at Abydos and dating from the 4th millennium BC, (British Museum, London).

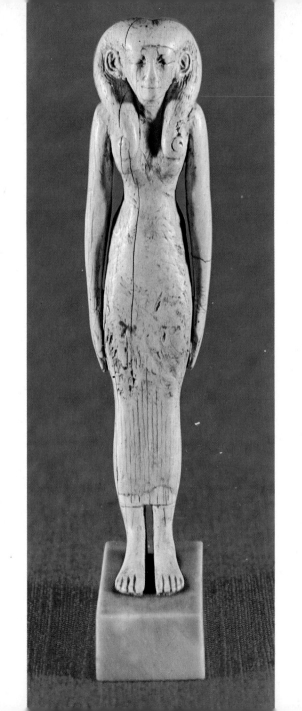

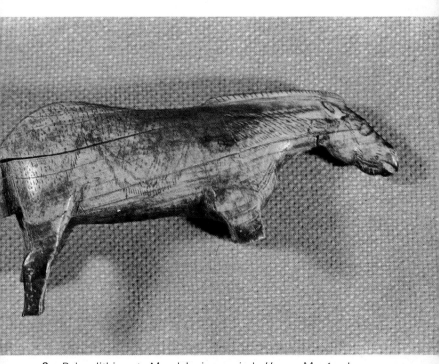

3 Palaeolithic art, Magdalenian period. *Horse*. Musée des Antiquités Nationales, St Germain-en-Laye.

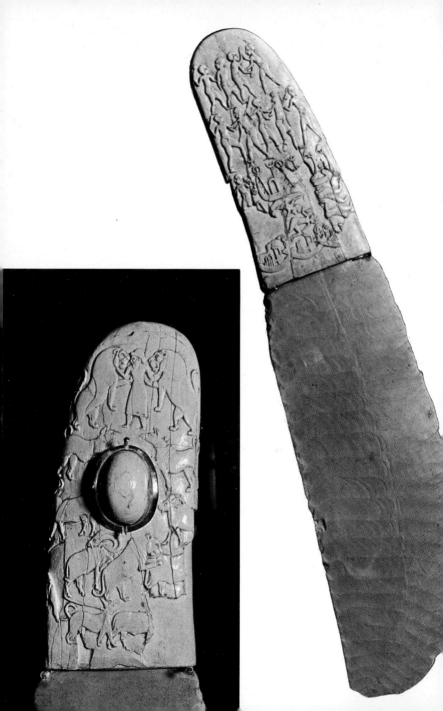

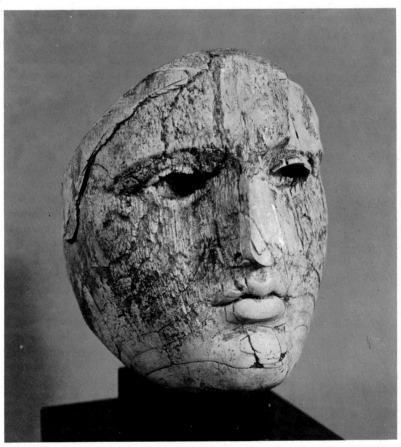

15 Greek art. *Chryselephantine head of a statue*. Museo
Vaticano, Rome.

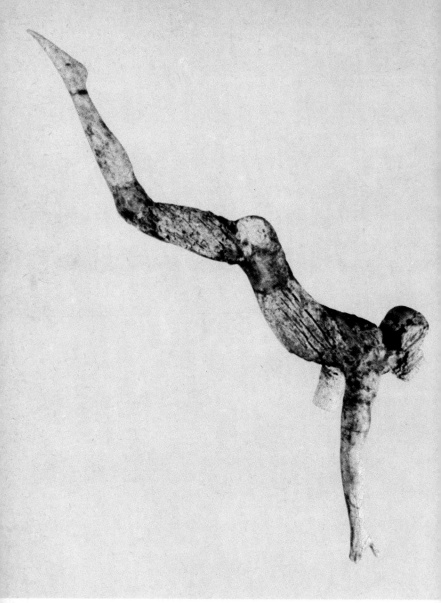

16 Cretan art. *The Acrobat*. Archaeological Museum, Iráklion (Candia).

13 Phoenician art. *Pyx* cover. Musée du Louvre, Paris. This particularly fine cover (14th century BC) was found at Minet el Beida-Ugarit; it represents the fertility goddess clothed as an animal tamer. The skirt is in the Cretan style.

14 Cretan art. *Snake goddess.* Museum of Fine Arts, Boston. The subject of this exquisite ivory statuette was popular among Cretan artists. The statuette probably dates from the 16th century BC. Its exquisite workmanship illustrates the skilful combination of ivory with gold, while its attitude shows a characteristic ability to convey awareness of both the sacred and the profane aspects of life.

15 Greek art. *Chryselephantine head of a statue.* Museo Vaticano, Rome. Photo Guidotti. Greek artists of the Classical period often combined ivory with gold and precious stones. This life-size head of the 5th century BC possesses a remarkable grave beauty.

16 Cretan art. *The acrobat.* Archaeological Museum, Iráklion (Candia). This agile and graceful figure of an acrobat somersaulting is of a rare beauty; it is easy to understand its great influence on the artists of Cyprus, Mycenae, Sparta and Argos. The Aegean cultures produced many such small figures, which were used in rituals and as domestic decorations.

Roman and Barbarian cultures coexisted, was considered more or less provincial. When the Roman rule was strong, Gallic and Germanic artists were influenced by the Romans and tried to copy their forms and models. By the 4th and 5th centuries AD, Roman power was on the wane, and the influence was felt in the other direction.

It was during the decline of the Roman central authority that the arts underwent an unexpected revival away from the old centre of the Empire, in Constantinople, Syria, Palestine, Gaul and northern Italy. It would be quite wrong to speak of any decadence in the arts, whatever the political, social and economic situation of the Empire. Art received new impulses from outside in the form of Barbarian arts, and from inside, where the revolutionary new Christian faith was giving Roman civilisation an essentially new character.

I repeat: the art of the time was not an art of decadence. Rather, it was an art which had freed itself from the weary, repetitive formulas of the past, and which was slowly and painfully searching for a way in which to respond to the fashions, imagination, spirit

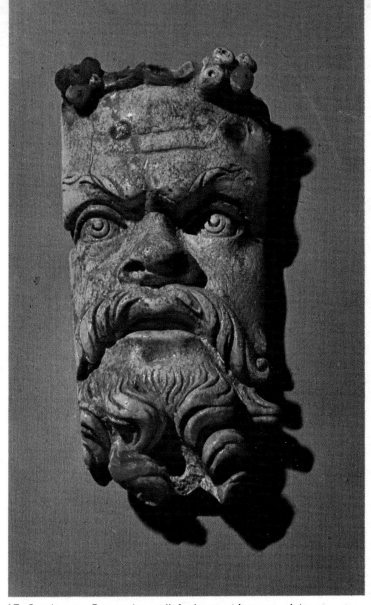

17 Greek art. *Decorative relief*. Agora Museum, Athens.

43

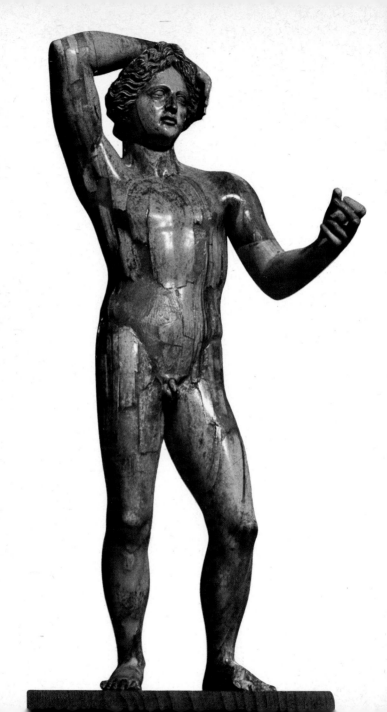

Imperial period became heavily dominated by the Hellenising taste of the ruling classes. From this point of view it is interesting to compare the statuettes and portraits in the round in the Vatican Library with Greco-Roman statuary.

Two objects were particularly popular with the Romans: the pyx, a cylindrical box made to contain jewels, and the diptych, two small hinged plaques with the inner sides covered with wax to form writing tablets. Ivory was put to new uses in Rome, where a taste for exotic articles and precious materials became increasingly marked with the growth of the Roman Empire. Ivory was used for the curule chairs, for thrones and sceptres, and even for the tables on which senatorial decrees were written. It was also used for decorating the doors of the wealthy, for their beds, and for seats, as in the Orient. Even under the first Christian emperor, Constantine, ivory remained a highly fashionable material.

Works in ivory were produced in quantities in ancient Rome. The early works were rather coarse repetitions of the forms and styles of an alien culture, but authentic and mature masterpieces were produced

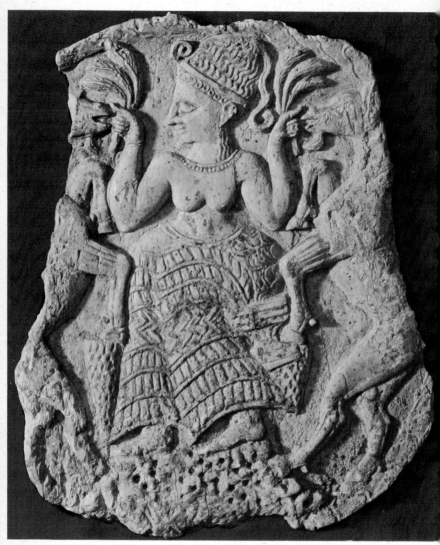

13 Phoenician art. *Pyx cover*. Musée du Louvre, Paris.

5 Egyptian art. *Female figurine*. A 'concubine of death'. Musée du Louvre, Paris.

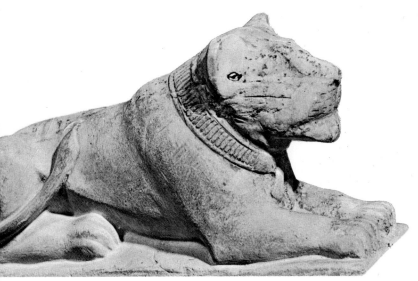

6 Egyptian art. *Lion*. Musée du Louvre, Paris.

5 Egyptian art. *Female figurine.* A 'concubine of death'. Musée du Louvre, Paris. Their belief in a life after death induced the Egyptians to furnish tombs with everything that might be of use to the deceased in the after-life, including figures of slaves and girls. This statuette belongs to the period when Thinis was the capital (1st and 2nd dynasties).

6 Egyptian art. *Lion.* Musée du Louvre, Paris. Probably a piece from a board game; it dates from the period of the earliest dynasties, with their capital at Thinis (beginning of the 3rd millennium BC). The lion, a symbol of royal power, was created from close observation of reality.

7 Egyptian art. *Figure of a man.* British Museum, London. Ivory carving was further removed from large-scale sculpture in Egypt than in any other ancient civilisation; in particular, ivory figures were related to everyday life. They display a precise and refined workmanship, an elegant linear style of composition and careful rendering of detail.

8 Egyptian art. *Ivory fragments with magical scenes.* Musée du Louvre, Paris. These probably date from the 15th or 16th dynasty (1680–1580 BC). The objects to which these fragments belonged have not been identified, but they were probably connected with a magical-religious cult or ritual.

7 Egyptian art. *Figure of a man.* British Museum, London.

9 Sumerian art. *Statuette of a man.* Musée du Louvre, Paris. For the Sumerians, all forms of art had a strict religious significance, a fact discernable even in this late work, influenced by Persian art of the Achaemenian period in the 6th century BC.

10 Sumerian art. *Ivory plaque.* British Museum, London. The technique and composition suggest that this plaque came from the Phoenician zone of influence. It is incised with a figure holding a long blossoming vine-shoot, a soothsayer's symbol. Note the winged disc, a symbol of the Solar divinity.

11 Phoenician art. *Cow and calf.* Musée du Louvre, Paris. This probably dates from the 9th century BC, and is skilfully composed within a strictly geometrical form. This motif – of a cow turning affectionately towards the calf it is suckling – is frequently found in Phoenician ivory sculptures.

12 Phoenician art. *The goddess Ishtar.* National Museum, Damascus. Important work was produced by Phoenician ivory carvers, though it is more notable for technical expertise than any real creative originality. This statuette was found at Ras Shamra, and dates from the 15th-14th centuries BC. The figure seems to be emerging directly out of the elephant's tusk; it betrays Egyptian influence in its hieratic pose and formal severity, and Aegean influence in its geometricity.

10 Sumerian art. *Ivory plaque.* British Museum, London.

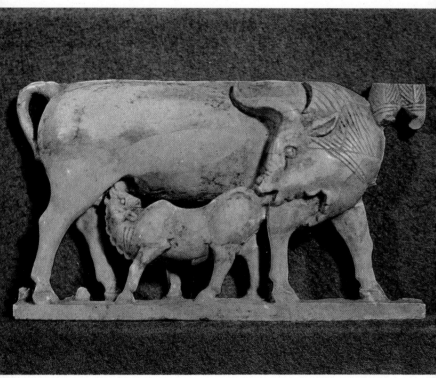

11 Phoenician art. *Cow and calf*. Musée du Louvre, Paris.

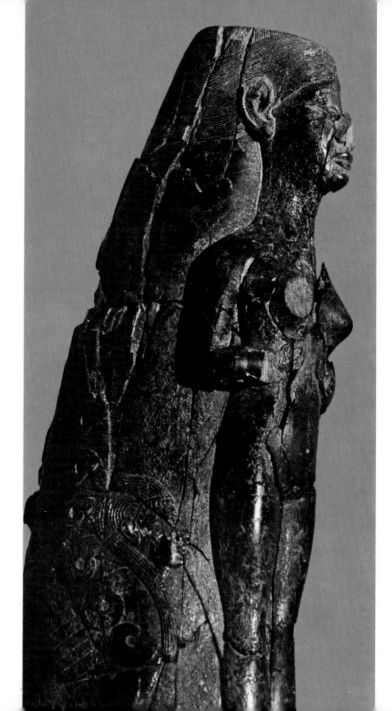

famous acrobat shown somersaulting in a ritual bull fight (plate 16).

Crete was to Classical Greece what Etruria was to Roman culture: a source of social and spiritual experience, with a rich fund of beliefs and myths upon which the succeeding culture could draw. Although contemporary with those of Egypt and Mesopotamia, the culture of Crete and the Cyclades produced an art that was noticeably different. Religion was still a potent source of inspiration, but Cretan art never assumed an overwhelmingly severe character. The objects found in Cretan and Cycladic tombs – small idols, mother goddesses, plaques worked in high relief with representations of hunting scenes, warfare and animals – reveal a freer, gayer sense of life than was to be found in contemporary Near Eastern cultures. The Cretan decorative sense was strongly geometrical in feeling, manifesting itself in compositions in which shapes were reduced to such elementary forms as the cylinder, the sphere and the cone. Art displayed a grace, a lightness of touch, and a subtle, fresh pleasure in the arrangement of forms, that were later transmitted to the mainland in the first period of Mycenaean

culture, and thence passed to Classical Greek culture.

It is well known that, in all its manifestations, the Hellenic spirit always kept its originality and independence. Even the small and rare ivory sculptures of the Classical period have this same quality of independent originality, and the wonderful sense of moral and aesthetic balance that was the basis of the Greek concept of life. Both the major and the minor arts were marked by a sense of rational measure, of which man was both the symbol and the criterion, and a strong conviction of the relationship between goodness and beauty. The Greeks made a bold and successful attempt to combine both the major and minor arts; the use of ivory not only in small works, but in large sculptures, with a technique which was given the name of chryselephantine, was characteristic of this attitude. The result was the creation of dazzling representations of divinities in which areas of flesh, made of ivory, were harmoniously combined with gold for the draperies and precious stones or glass for the ornamentation of the figures, which were set above wooden cornices. Outstanding examples were Phidias' Pallas Athene, gazing over the city from her eminence

on the Parthenon, and Polycleitus' Hera in Argus, which so captured the imagination of Antiquity.

Marble and bronze were the materials most often used in Greek sculpture, and during the whole of the Classical period the use of ivory on its own was restricted to minor works. But this minor sculpture was not merely imitative of large-scale sculpture, although it closely followed it in stylistic development. As in Egypt, the purpose of minor sculpture was different from that of monumental works, and it became a more intimate and popular form of art. Only a few works have survived intact, but that few – comparable with the small bronzes of the Greeks and the Tanagra terracotta figurines – graphically convey the spirit of this minor art.

The Roman habit of copying what were considered to be the best examples of Greek sculpture was not confined to large-scale statuary. Reliefs, statuettes and objects in everyday use were all more or less influenced by Greek models. However, the popular character of minor sculpture ensured that it would have affinities with Etruscan taste; it was to remain apparent in ivory works even when the sculpture and jewellery of the

in the early Empire, with refined, gracious modelling and flattened volumes which still suggested the fullness of figures in the round. Roman realism and pathos were combined with the Classical Greek style in works which displayed a somewhat baroque spirit. In my own view, the finest works illustrating this tendency are the two plaques decorated with Bacchic scenes in the Museo Nazionale, Naples, and the Orphic pyxes at Florence and Vienna; for although the production of ivory works in the Alexandrian style was prolific enough, it was decidedly inferior.

The irruption of the Barbarian peoples into the Roman Empire had important consequences for the development of art. The golden mean, the idea of man, the lucid Greek canons of beauty, came into contact with the inventive fantasy of the Barbarians, their search for greater expressiveness and emotion, and their tendency towards a kind of geometrical abstractionism to which contributions were made by the Scythians, Sarmathians, Huns, Celts, Scandinavians and others. The result was a new conception of art, and a taste for taut linear patterns. At first the art produced in the zones of tension, where Greco-

14 Cretan art. *Snake goddess*. Museum of Fine Arts, Boston.

17 Greek art. *Decorative relief.* Agora Museum, Athens. Although the Greeks produced relatively few ivory objects, this skilfully carved relief of the 2nd century BC demonstrates the use of ivory for the decoration of furniture.

18 Greek art. *Apollo Lykeios.* Agora Museum, Athens. Greek ivory carvers made use of the styles and techniques of large-scale sculpture in their work. The gentle rhythms of the body are stressed by the placing of the arms and the slightly bent left leg; they are characteristic of the perhaps over-elegant aesthetic feeling of late Hellenic civilisation.

19 Etruscan art. *Arm.* Museo di Villa Giulia, Rome. This work of the 7th century BC may have been a mirror handle. It comes from the Barberini tomb at Palestrina. The entire surface of the arm is covered with relief decoration consisting of animal and plant motifs in the Eastern style.

20 Etruscan art. *Female statuette.* Museo Archeologico, Florence. The woman holds a small vase in her right hand and cradles her breast with her left hand, a gesture typical of the Asiatic fertility goddesses. There are many other direct references to Oriental art in the work, and the body was originally covered with a thin layer of gold, of which traces may still be seen. It dates from the 7th century BC and came from the Etruscan necropolis of Marsiliana d'Albegna.

21 Roman art. *Ship and crew.* Museo Vaticano, Rome. Photo Guidotti. Probably a toy or a virtuoso piece made to display the sculptor's talent for miniature figures. The mast, the pilot's left hand and the rudder are missing. This curious, exuberant little work dates from the age of Constantine.

18 Greek art. *Apollo Lykeios.* Agora Museum, Athens.

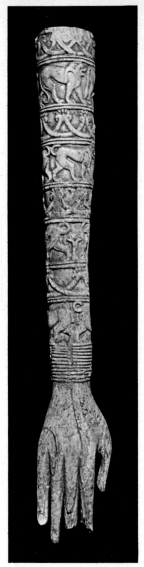

19 Etruscan art. *Arm*. Museo di Villa Giulia, Rome.

20 Etruscan art. *Female statuette*. Museo Archeologico, Florence.

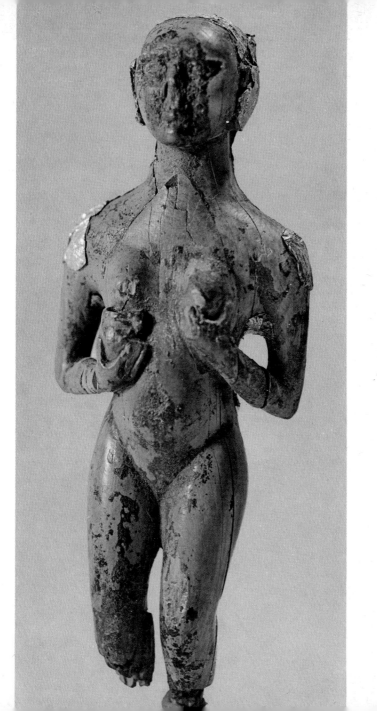

and aspirations of the new society that was gradually emerging.

The Classical spirit that still permeated bas-reliefs, statues and ivories had very little in common with the neo-Attic art of the first and second centuries AD which was still imbued with the Hellenic spirit of purity. In art, there was a new spirit which was determined to make basically new use of its experience in the light of new ideas, combining the old, soft, plastic forms in a new style characterised by a taste for vigorous, clearly defined volumes. The new artistic sensibility that spread seemed to find ideal conditions for its affirmations both in the East and in the West, while the expressive language of art soon lost all local characteristics as it became cosmopolitan.

In a complex contradictory world that was henceforth polycentric and in which paganism disappeared (although leaving strong traces which were only rejected in religion), in which the new faith developed its own rigorous doctrine while dogmatic disputes broke out on every side, intellectual exchanges were open and lively and knew no frontiers. The man of culture and the Roman artist were equally at home in

Constantinople and in Alexandria, just as a Greek or a Syrian felt themselves at home in Rome. The result was a kind of intellectual cosmopolitanism, which may have been partly snobbish in origin, with patrons seeking for exotic artists and vice-versa.

EARLY CHRISTIAN AND BYZANTINE IVORIES

The rise of Christianity had an even more decisive influence on Roman civilisation than contacts with Barbarian cultures. A new idea of the world gained currency, replacing Classical realism with belief in an extraterrestrial life regarded as a kind of higher, limitless reality. The new function of art was to express the ineffable (as it had already done in early civilisations with strong religious preoccupations). Art was also intended to give material expression to the spirit liberated from the world of appearances, and to symbolise man's slow ascent to the divine.

In the early phase of tension between pagan and Christian art, the old, time-honoured forms were

simply given a new Christian content. The same objects continued to be made. Pyxes, which had once had a specifically profane use, and were decorated with scenes of hunting or games, were used in Christian churches as containers for the sacrament. Diptychs, which had once been presented by the consuls to the emperor at the moment of investiture, became writing tablets to be used during the divine service; the names of magistrates were replaced by those of bishops, just as the ornamental scenes of circus games gave way to representations of saints and angels. The same process occurred in all the arts: a long, slow adaptation of pagan forms and themes to the requirements of Christianity. At Alexandria and Constantinople, Imperial iconography was annexed by Christian artists; the best example of all is the throne of Archbishop Maximian at Ravenna (plate 30), a masterpiece of ivory sculpture in the Byzantine style, with figures of saints combined with scenes from the life of Joseph, and frieze decoration in the finest pagan style.

The other-worldliness of Christianity, with its vision of the City of God as the object of man's striving,

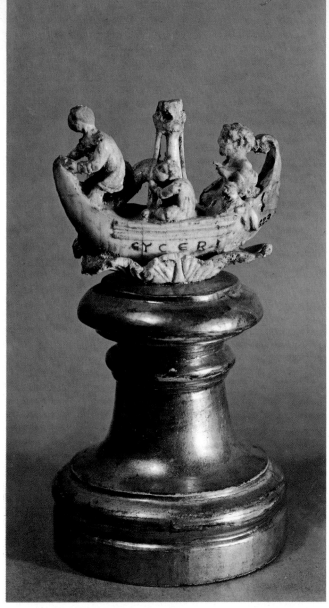

21 Roman art. *Ship and crew*. Museo Vaticano, Rome.

22 Roman art. *Doll.* Museo Vaticano, Rome. Photo Guidetti. An interesting example of the art of the 3rd century AD. The arms and legs are missing. The face and chest are executed in a rather coarse and summary fashion, but the headdress is carefully modelled in the style current in the second half of the 3rd century.

23 Roman art. *Standing putto.* Museo Vaticano, Rome. Photo Guidotti. A small ivory relief figure of a naked infant with a cloak over his left shoulder. It is very precisely modelled, and the facial expression is rendered with striking realism. 3rd or 4th century AD.

24. Roman art. *Seated boy holding a hare.* Museo Vaticano, Rome. Photo Guidotti. This object was found in 1920, during excavations of the cemetery of Panfilo. It must have served as a knife or dagger handle. The realistic treatment of the boy and animal was a characteristic of Roman ivory art, in marked con- trast with the Hellenising style of large-scale sculpture. The work dates from the 3rd or 4th century AD.

22 Roman art. *Doll.* Museo Vaticano, Rome.

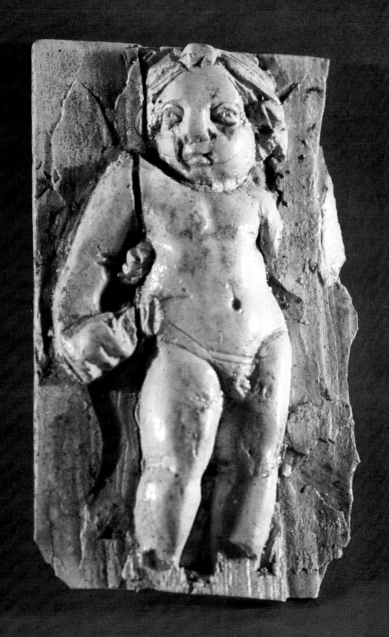

24 Roman art. *Seated boy holding a hare*. Museo Vaticano, Rome.

23 Roman art. *Standing putto*. Museo Vaticano. Rome.

inevitably led to a decline of interest in representing reality. Sculpture in the round was neglected, and the art became a kind of ancillary to architecture or a minor form of expression almost exclusively confined to reliefs. Ivory was an ideal medium for such limited ambitions, and it became one of the most commonly used materials for carving; the Early Christian period was the golden age of ivory. In relief sculpture, whether on stone sarcophagi or on ivory, figures lost their three-dimensional forms and were represented simply by lines and flat surfaces, as in the hieratic *St Mena Between Two Camels* (plate 36). All the same, many Early Christian ivories retained a characteristic Roman plasticity and sense of volume, albeit subdued.

Everything that had been realistically depicted in the Roman period was now represented by line alone. Such a style eliminated the sense of material presence, and displayed affinities with Eastern figurative art. Barbarian influence was most apparent in the tendency to translate figures into rhythmic patterns, and in a taste for nervous decoration in which fantasy was given free rein. Figures were represented frontally and symmetrically, and were surrounded by delicately

drawn, interlacing patterns of lines, geometrical motifs, symbols and allusions, all intended to give decorative harmony to the overall composition. This decorative scheme was derived from the Eastern and Barbarian cultures, as was the use of geometrical schemes in the representation of a resolutely anti-naturalistic vision of the world.

With the collapse of the Roman Empire in the West, Constantinople became the centre of a new and distinct culture that was in part Greek and in part Oriental: the East Roman Empire, more commonly called Byzantium, was to endure until 1458. After the city had been rebaptised as Constantinople, it attained a position of prime importance in politics and administration and the logical consequence was a formidable leap forward in every aspect of life, art and culture included.

Necessity and prestige combined can work miracles and, in the space of a few decades the city was completely transformed. Sumptuous palaces and great Christian churches were built, and artists and architects came streaming in, to bring about an encounter between the liveliest Classical tradition in the

Greek style and the fresh authentic elements of nearby Oriental culture thus illustrating another aspect of the important synthetic function that the city had assumed in a short time.

Once the Hellenistic styles of late Imperial Rome had been assimilated in the 4th and 5th centuries, such typically Oriental tendencies as symmetrical, vertical, frontal compositions derived from Palestinian and Syrian art made their way into Byzantine art. By the 6th century it had developed a rhythmic style of its own which spread rapidly throughout the Asian provinces of Byzantium and then through old Roman Europe, where it assumed a kind of universal character. Rome, Milan and Ravenna soon became vigorous outposts of the Byzantine style.

Ivory work made an important contribution to Byzantine pre-eminence in the arts, thanks to the qualities of the material: its rich range of white and yellow tones, its extraordinarily fine grain, and the countless possibilities it offers for delicate, lace-like workmanship. Byzantine craftsmen were always quick to recognise the artistic possibilities of a precious material, and ivory had all the requisite qualities to

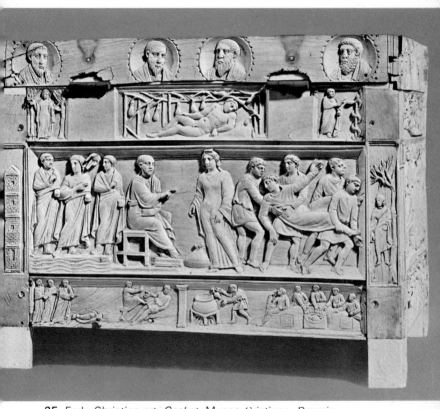

25 Early Christian art. *Casket*. Museo Cristiano, Brescia.

25 Early Christian art. *Casket.* Museo Cristiano, Brescia. During the 4th and 5th centuries AD, ivory sculpture flourished again. Marble sarcophagi inspired the rich decoration of ivory caskets and cases. The casket reproduced here dates from 360–370 and is one of the finest of its type.

26 Early Christian art. *Diptych of the Symmachi and the Nichomachi.* Musée de Cluny, Paris, and Victoria and Albert Museum, London. The diptych was made to commemorate the marriage between two great Roman families in the early 5th century AD, and in composition and subject-matter (female priests making sacrifices) it belongs to the Classical tradition of celebratory diptychs. The serene and harmonious composition is also clearly Hellenic in inspiration.

27 Early Christian art. *Wing of the Lampadi diptych.* Museo Cristiano, Brescia. A circus scene with three members of the Lampadi family seated in the tribune. The forms are denser and more geometrical than in the previous example, evidence of the Barbarian influences that were at work in 5th-century art. The entire diptych is composed in a geometrical style heralding later decorative fashions.

28 Early Christian art. *Wing of the Basilius diptych.* Museo del Castello Sforzesco, Milan. A winged victory holds a shield with the effigy of Basilius, who was consul at Rome in AD 480. The characteristics of Classical art have been completely abandoned in favour of a plastic violence and a rather abstract stylisation which reinforces the expressive value of the lines.

26. Early Christian art. *Diptych of the Symmachi and the Nichomachi* Musée de Cluny, Paris, and Victoria and Albert Museum, London.

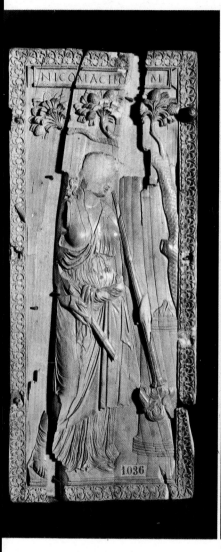

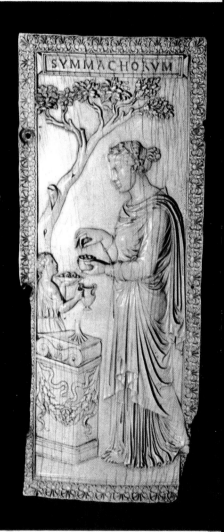

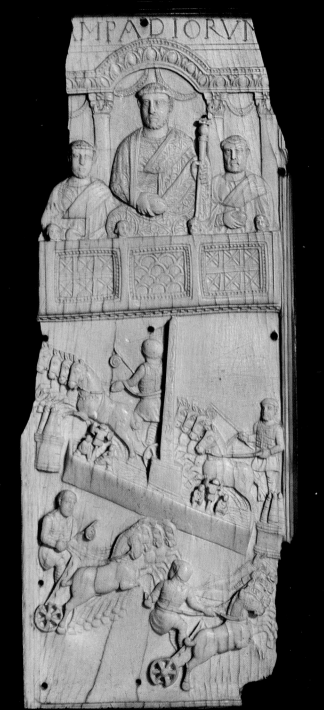

28 Early Christian art. *Wing of the Basilius diptych*. Museo del Castello Sforzesco, Milan.

27 Early Christian art. *Wing of the Lampadi diptych*. Museo Cristiano, Brescia.

satisfy the taste for refinement and fantasy in art, which had been developed by the cultivated classes of the entire Greco-Roman world. Another reason for its popularity was the decline of interest in sculpture in the round, whose possibilities seemed to have been exhausted in the representation of man, and which seemed less suitable for representing man in his relationship with the other world.

Religious and profane themes appeared in such ivory carvings as bishops' chairs with inlays, diptychs, boxes, portraits executed for nobles, consoles, and chess pieces. Representations of the Byzantine Imperial family include one of the empress herself in all her pomp, wearing a heavy diadem, in the beautiful 6th-century plaque in the Bargello, Florence.

This flourishing art was inspired by the traditions of both the late Empire and Early Christian culture. Diptychs and triptychs were the objects on which religious scenes were most frequently carved, and they became in effect household altars, displaying marked affinities with the style of monumental art.

Other ivory works of note were the famous rectangular caskets, which were usually decorated with circus

scenes or ancient gods and heroes. Quite exceptional plastic and dramatic effects were often achieved, and the decorations are often rendered with a tenacious realism that breaks through the elegant symmetry of the compositions. Later ivories displayed a greater stress on stylisation, as in the Harbaville triptych (plate 32), a work probably dating from the 10th century, with a calculated emphasis on light and shade effects.

Byzantine culture was complex and sophisticated, and it is not difficult to understand how greatly it impressed the peoples of cultures with which Byzantium came into contact. It was destined to influence the entire artistic production of a large part of Europe for several centuries.

THE EARLY MIDDLE AGES

The Byzantine emperors' hostility towards figurative art in the 7th and 8th centuries – the famous iconoclast controversy – led to a period of stagnation in the art of the Near East. In the West, where political and social

conditions were more unsettled, conditions were unfavourable for minor arts like ivory carving. Only when Charlemagne brought a new order to Europe, enabling the Barbarian peoples to take over what remained of Roman civilisation, did painting, architecture, sculpture and the minor arts begin to flourish again.

The fertile imagination of the new peoples of Europe gave them the ability to assimilate the styles and creations of the old Classical and Early Christian cultures and re-elaborate them in new and complex forms. But they also fell under the important influences of Byzantine culture, especially in northern Italy where contact with the eastern Empire was greater.

Ivory work was influenced by the Barbarian taste for light and shade contrasts, and by the Barbarian sense of form and rhythm, which was gradually transferred from geometrical to figurative compositions; the conversion of pagan peoples to Christianity gave impetus to this process. Ivory plaques began to be carved for the first time, and with great success, for the covers of books. Ivory reliefs were inlaid between rows of hard gems so that the soft white appearance of the

ivory would heighten the sheen of gold and the splendid colouring of precious stones. To decorate the Gospels, craftsmen used the symbols of the Evangelists, scenes from the life of Christ – the miracles, the Passion – and, most popular of all, King David and illustrations of the psalms.

Ivory was also used for other objects, such as holy water stoups (an invention of the Merovingians), panels for altarpieces, buttons and combs used in ceremonies of episcopal consecration, and the croziers of church dignitaries.

The peoples north of the Alps made a massive and original contribution to European ivory art. On both sides of the Rhine, particularly in the region of Aachen where the court resided, the Carolingian restoration of the Empire gave the legacy of antiquity a way in which to express itself politically within the context of a new Roman Empire created by a Germanic nation. This symbiosis gave rise to a singular new type of civilisation. In the figurative arts such as painting and sculpture, the Germanic style still echoed the Classical tradition which had filtered through from Byzantium, but only in its external aspects, for the essence was no

29 Early Christian art. *Apollo and Daphne*. Museo. Nazionale, Ravenna.

30 Early Christian art. *The throne of Archbishop Maximian*.
Museo Arcivescovile, Ravenna.

29 Early Christian art. *Apollo and Daphne.* Museo Nazionale, Ravenna. Art acquired special characteristics at Ravenna, where Eastern influences were particularly strong. The originality of the art of Ravenna can be seen even in ivory reliefs such as this one, with its rich linear and formal decoration; the figures have become depersonalised rhythmic elements in the overall composition.

30 Early Christian art. *The throne of Archbishop Maximian.* Museo Arcivescovile, Ravenna. This work of the mid 6th century can be regarded as the culmination of Early Christian and Byzantine ornamental fantasy. The frieze decoration of plants around the figures displays the wonderful skill of Ravenna workmanship. The figures themselves are separated and yet not unrelated to one another.

31 Byzantine art. *Diptych with personifications of Rome and Constantinople.* Kunsthistorisches Museum, Vienna. Scholars disagree as to whether this is the work of a Western or a Near Eastern artist. The rigid schematism and symmetry seem to belong to Syrian art, which had filtered into early Byzantine art; but certain Classical elements seem to indicate a Western provenance for the work. This uncertainty stems from the extraordinary meeting and mingling of unlike styles and cultures in 5th-century Europe.

32 Byzantine art. *The Harbaville triptych.* Musée du Louvre, Paris. The figure of Christ, set high in the centre, takes the place formerly occupied by the emperor, between the sun and the moon. Art historians have discussed whether this facile transference from pagan iconography, together with the tenaciously surviving Classical style of some of the figures, are indications that the work dates from the 5th century; but the general opinion is that it belongs to the 10th century.

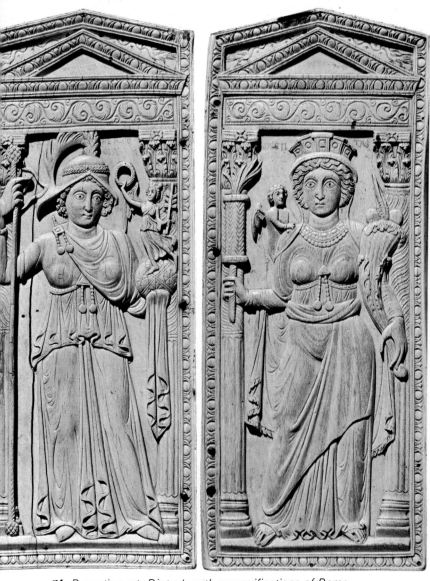

31 Byzantine art. *Diptych with personifications of Rome and Constantinople.* Kunsthistorisches Museum, Vienna.

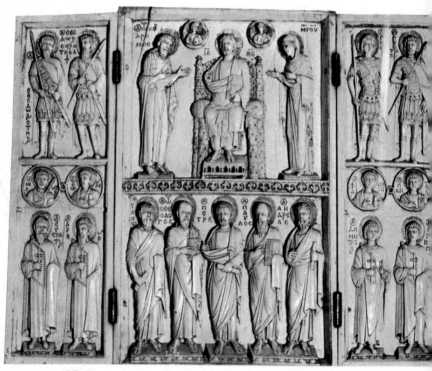

32 Byzantine art. *The Harbaville triptych*. Musée du Louvre
Paris.

longer the same. At the same time, links with the old culture rapidly became looser as art became more anti-Classical in spirit.

Medieval art contained elements of both its sources; but despite the many echoes of Hellenistic and Early Christian art, the overwhelming impression is of a pronounced and original tendency towards stylisation and ornateness. The Carolingian 'restoration' of the Roman Empire led to the development of a new culture and a new art on both sides of the Rhine, and particularly at Aix-la-Chapelle (Aachen), where the court resided. In the numerous Medieval ivory-reliefs, landscape and buildings were freely composed on a single plane without any organic relationship between them. Figures, volumes and decorative elements seemed to become dematerialised. Groups of figures had greater spontaneity; masses that had at first been enclosed and compressed tended to become freer; the rigidly rectangular shape of compositions tended to disappear – with the result that they extended in space with greater ease and freedom, and covered the entire plane. The rhythmic, rigid, symmetrical style inherited from Byzantium was virtually abandoned.

Examples of the new ivory art in the Rhine region include some splendid book covers made in the 9th century for the Archbishop of Metz; this suggests that there may have been a school of ivory artists in the city. A few decades later, other fine works were produced in the monasteries of St Gall and Reichenau. Later Trier and the central Rhine region became important, followed during the Ottonian period (10th and 11th centuries) by the lower Rhine region and Flanders, where the most important centre was Liège.

The art produced by these important centres gradually became influential all over Europe. Southern France developed an elegant style of its own, but the influence of the Rhenish style was felt in Cologne, Milan and even as far as southern Italy, where an 11th-century masterpiece, the altar frontal in Salerno cathedral, is in a style that already heralds the Romanesque.

In southern Italy there was a strong influence from Islamic culture. Ivory was often used by the Arabs, whose extraordinary decorative imagination and passion for the play of light and colour were expressed

in a wide range of objects. In ivory bas-reliefs, the surface would be entirely covered with fine geometrical patterns, elegant floral motifs and calligraphic signs; this style was to reach even greater heights in ceramics, silk and linen textiles, and, in the 13th century, the splendours of Islamic miniatures. Islamic civilisation remained faithful to its traditions over the centuries, as is revealed by a comparison between the cylindrical case made in the 10th century for a son of Abd-al-Rahman III (Louvre, Paris), decorated with rather abstract figures of horsemen and animals, with Spanish Arab or Mozarabic works two centuries later, or with the Arab-Sicilian works of the 14th century.

It is difficult to appreciate the esteem in which ivory was held until at least the end of the Middle Ages. The material imposes severe limits on the artist, and demands a precise technique, many aspects of which are comparable with that of miniature painting. This is demonstrated by the detailed instructions left by the monk Theophilus. He recommended that before pieces of ivory were carved, they should be covered with a thin layer of *gesso* in which outlines could be drawn with a pointed instrument. He accurately listed

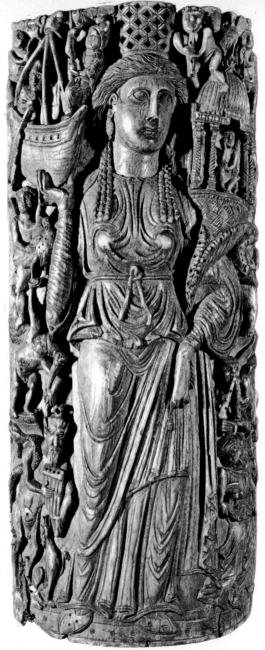

33 Byzantine art. *Alexandria-Isis*. Aachen Cathedral.
34 Byzantine art. *The Emperor Justinian on horseback*.
Musée du Louvre, Paris.

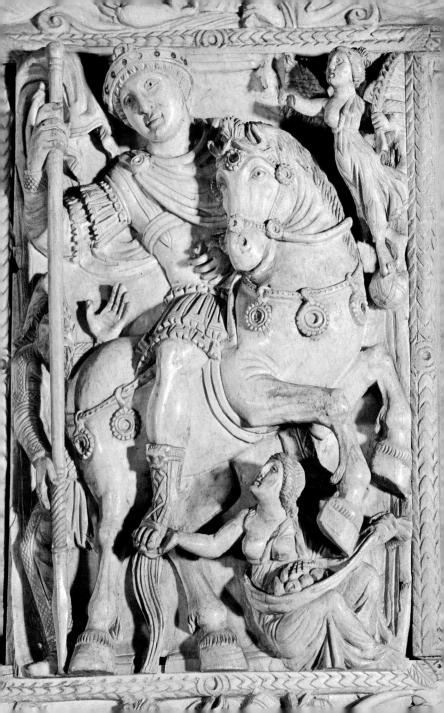

33 Byzantine art. *Alexandria-Isis.* Aachen Cathedral. This idealised portrait of Alexandria, costumed as Isis, reveals the taste for pomp that was typical of Alexandrian art in the 6th century. The solemnity and decorative superabundance of the relief are reminiscent of certain Eastern works, and contrast with the grave, detached expression of the face.

34 Byzantine art. *The Emperor Justinian on horseback.* Musée du Louvre, Paris. Another image almost smothered by decoration. Here, however, the sense of space has been skilfully rendered by means of light and shade effects, open and closed areas and foreshortening effects, all of which give the work a vigorous expressive power. Note the survival of Roman realism in the treatment of the horse.

35 Byzantine art. *Madonna and Child and Adoration of the Magi.* British Museum, London. One of the first examples in iconography of the Madonna and Child — a subject that was to be greatly developed from the early Middle Ages. This work dates from the 6th century, and the attitudes of the figures and the facial expressions display a clear tendency towards a transcendental abstractionism incarnating an idea outside space and time.

36 Coptic-Byzantine art. *St Mena Between Two Camels.* Museo del Castello Sforzesco, Milan. The static quality of this beautiful plaque, the severely controlled symmetry of the composition, and the essential simplicity of structure make it one of the most striking works ever produced by the Eastern Christian tradition of art. Although some scholars have dated it to the 11th century, it seems more likely to have been made in the 6th century.

35 Byzantine art. *Madonna and Child and Adoration of the Magi.* British Museum, London.

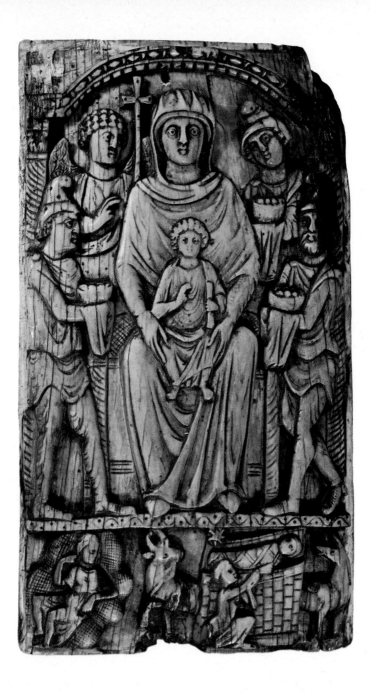

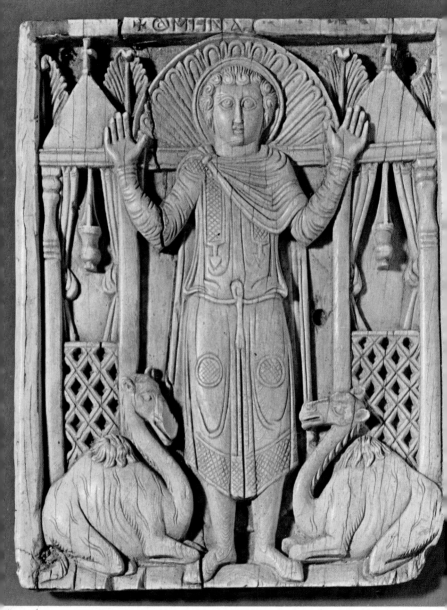

36 Coptic-Byzantine art. *St Mena Between Two Camels.*
Museo del Castello Sforzesco, Milan.

the various scalpels used for incising the surface, and recorded other pieces of advice – how to give ivory a reddish tint in order to avoid excessive light reflections, how to immerse ivory strips in boiling vinegar and wine so as to make them as soft and flexible as wax, etc. Theophilus also states his opposition to the use of large pieces of ivory, asserting that preference should be given to small pieces of ivory which could be superimposed.

The skill and technical knowledge of these obscure monastic artists, who created most of the ivory carvings of the early Middle Ages, and of whom Theophilus is the best known, soon became outstanding. The material was exploited to give maximum expressiveness, and the style was determined by the material itself; lines were drawn with almost surgical precision, and their hardness was tempered by the softly glowing surfaces.

The vibrant, exalted compositions of the 9th century were followed in the 10th by a type of composition in which a calmer style prevailed. This style was anti-naturalistic, and even tended towards an idealising abstractionism. But Western art never

entirely shook off a tendency towards realism, as is shown by the Crucifixion made for the cover of the Echternach codex in about 990.

ROMANESQUE AND GOTHIC

In the 11th century a new spirit was abroad in Europe, and with it a new approach to architecture and the other arts, manifested in the Romanesque style. Among other things this entailed a resurgence of figurative art. The enduring influences of Byzantine art were now reabsorbed or re-elaborated in more original forms, though as a kind of formal rather than a substantial factor. In ivory art, a sense of majesty was created by a plastic modelling that accepted the promptings of natural truth while also displaying an extreme susceptibility to sudden outbursts of fantasy which, in Germany especially, exploited all the resources of line. Patterns became livelier and more rhythmic, forms became softer and more free-flowing, and the artist's chisel rendered minute detail with loving care. Once again there was an evident desire

for elegance, a more elaborate expressiveness, and a vogue for the fantastic, the mystical, the monstrous, which was in part influenced by contacts with the Arabs and Persians. Lines, masses, forms, volumes and spaces became interlaced in a vital, vortex-like confusion. Shapes became deformed, proportions abnormal and space overturned. The monsters that were created were simply the concrete expression of dreams born out of a fantastic imagination like some muted echo of ancestral superstitions of magic and prodigies (see the Ascension of Christ in Berlin Museum, dating from *c.* 1100). The period was characterised by a diffuse, conscious and unconscious intellectual curiosity concerning things that belonged to the 'other world' or were strange in themselves. This curiosity found its outlet and concrete form in a lively desire for culture, and great structural and stylistic possibilities, and an enrichment of the language of art now that the old formulas of the early Middle Ages were no longer found satisfying.

Ivory objects of the period include bishops' croziers, decorated with vegetal and animal themes, and the type of staff called a *tau,* which was used by

church dignitaries and ended in a sculpted handle featuring carved shapes, interlacing patterns and symbols like the sculpted capitals of columns. However, ivory objects were no longer being created for almost exclusively liturgical use. Ivory caskets, oliphants (hunting horns), knife and sword handles, chess pieces, combs and feminine ornaments began to make their way into the homes of the wealthy. As sculpture resumed its former importance, ivory carving tended to imitate it, thus moving away from the art of the jeweller and goldsmith. The figures carved on the portals of churches now began to inspire the images, forms and expressive content of ivory carvings, determining and transmitting a sense of veneration destined to liberate mankind from universal chaos. The reference to the image became more immediate, and was better able to define the nature of a spirituality that now tended towards emotions closer to mankind than the sense of the sacred. At the same time, the process led to a reaffirmation of the liberty of the artist. Meanwhile (as may be seen in some 13th-century French works such as the *Battle of the Amazons* in the Louvre) a less allusive and ideo-

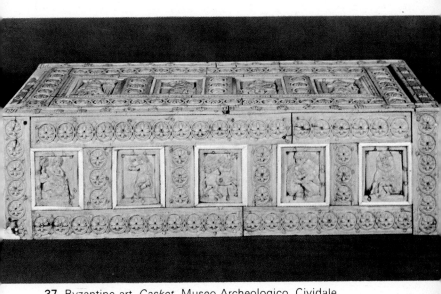

37 Byzantine art. *Casket*. Museo Archeologico, Cividale.

37 Byzantine art. *Casket.* Museo Archeologico, Cividale. A rare object, from the 10th century. It was for secular use, and is decorated with elegant geometrical motifs. The rectangular ivory caskets created by the Byzantines became justly famous and were only rivalled by a few late Gothic pieces.

38 Barbarian art. *Cover for the Echternach evangelistary.* Germanisches Nationalmuseum, Nuremberg. In the Dark Ages artists began to bind sacred books between covers decorated with reliefs in ivory and multi-coloured gems – a way of expressing the Barbarian taste for fanciful geometrical decoration. This 10th-century work from Echternach is a curious and interesting illustration of the way in which Germanic ornamentation went hand in hand with a realism that was never quite eradicated.

39 Barbarian art. *Comb with a Crucifixion scene.* Schnütgen Museum, Cologne. This 9th-century work is a splendid example of the high degree of technical skill reached in German ivory art. The openwork rose motifs and the foliage are carved with great delicacy.

40 Lombard art. *Ivory bucket of Godfred.* Cathedral treasure, Milan. The precise, free carving in this work illustrates the Lombard tradition, which reaches great heights. This masterpiece comes from the 10th century.

38 Barbarian art. *Cover for the Echternach evangelistary.* Germanisches Nationalmuseum, Nuremberg.

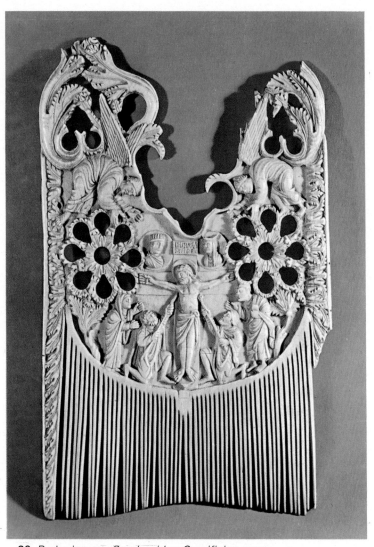

39 Barbarian art. *Comb with a Crucifixion scene.*
Schnütgen Museum, Cologne.

40 Lombard art. *Ivory bucket of Godfred*. Cathedral treasure, Milan.

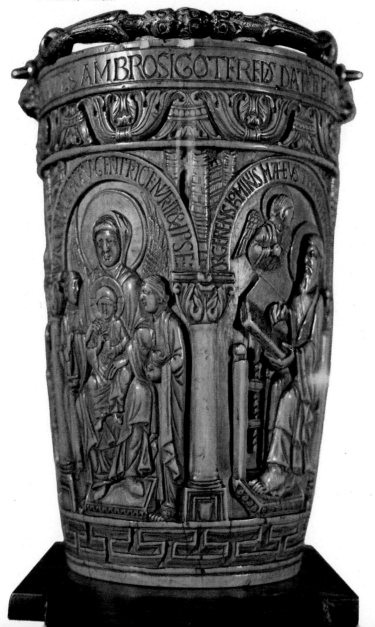

grammatic reference to the world resulted in a vigorous *rapprochement* between art and perceptible reality, thus foreshadowing further developments in the near future.

Art has seldom corresponded more closely to a society than in this period. All over Europe, the feudal system which was the framework of society gave tone and form to life and became the basis for the first unified states and modern nations which were to coexist in a subtle but fundamentally secure equilibrium. As a consequence of the new political conditions, economy made a great leap forward, with all the social consequences that such a progress implied.

Court life flourished around the castles that were springing up all over the continent and the British Isles. As power and wealth became concentrated in the hands of the new ruling class, they gave a new sense to life, and spread a taste for existence in which it was both possible and permissible to combine earthly pleasures with the metaphysical demands of man's relationship to God. A new existential idea was born which accentuated the detachment of anguished subjection from the transcendent sense of earlier

centuries. Without considering the new structures of society it is difficult to understand the sense and the aspects of Gothic art.

The centre of gravity and culture moved to the north-west of Europe where the unitary states became stable while the Mediterranean region, which was at another stage of social development, still remained under the more or less dominant influence of the Islamic world. As a result there were two great centres of power and civilisation in conflict with each other, although there continued to be a lively interchange of intellectual and artistic ideas which gave impulse to the forces of civilisation that were working below the surface.

During the 12th century, Europe underwent an intellectual renaissance, accompanied by renewed interest in man and the world of man. Abbot Suger of St Denis, the progenitor of the new Gothic style, had no hesitation in recommending life in the world as a path to God; God manifested himself in, and could be known through, earthly things. Reality became an object of investigation, partly interpreted through the rediscovered literature and art of Classical Antiquity,

whose spirit men tried to reconcile with that of the Christian faith. This symbolic explanation of the visible world by means of a process of universal import which tended to bridge the gap between the world and the spirit, while doctrine and dogma remained as unyielding as ever, seemed to respond to the emotional upsurge of the time which first found expression in anguished, monstrous, fantastic visions. It was a sign of how greatly man's relationship to the world around him and the world above him was changing. Men also began to resume a free and easy dialogue with nature which became a great source of observation and inspiration. But nature was still transfigured and far removed from the richer and more tender realism of the Renaissance. Consequently, there was an increasing re-evaluation of perceptible and individual reality beside which the ideas of the 'universalists' appeared as convenient schemes and it was thus that another revolutionary element made its way into the basis of the entire Medieval civilisation.

Both the major and the minor arts also helped to throw light on a dialectical relationship in its human aspect. If works of art are the most trustworthy

41 Barbarian art. *Hunting horn*. Supposed to have belonged to Charlemagne. Schatzkammer, Aachen.

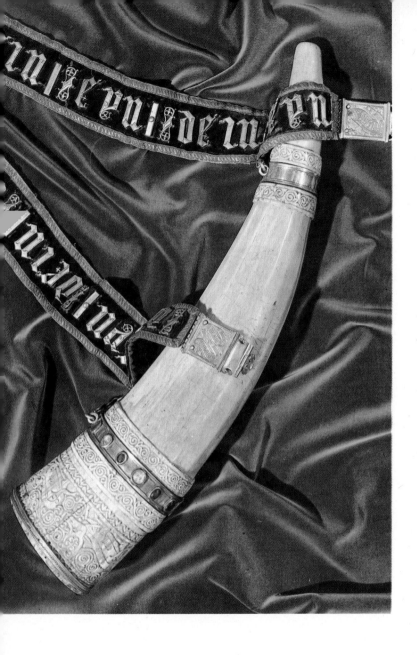

93

41 Barbarian art. *Hunting horn,* supposed to have belonged to Charlemagne. Schatzkammer, Aachen. Ivory horns for secular use were made almost throughout the Middle Ages, when artists mainly produced objects for ritual or devotional use.

42 Arab art. *Ivory horn.* Herzog Anton Ulrich Museum, Brunswick. Arab influence prevailed in the Mediterranean area during the 8th and 9th centuries. In southern Italy, where this horn was made, all the arts came under this influence, resulting in a profusion of fantastic decorative motifs and a somewhat bizarre elegance.

43 Barbarian art. *The Visitation.* Bayerisches National-museum, Munich. It is still a matter of dispute whether this magnificent plaque was made at Milan or in Germany. It does, however, date from the 10th century and is a typical example of the prevailing idealistic-abstract trend in European art.

44 Romanesque art. *Altarpiece.* Salerno Cathedral. The Italian Romanesque was heralded in this 11th-century altar-piece, which, like all works of the period produced in southern Italy, harmoniously combined European, Islamic and local traditions.

42 Arab art. *Ivory horn.* Herzog Anton Ulrich Museum, Brunswick.

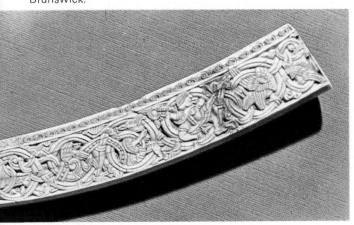

43 Barbarian art. *The Visitation*. Bayerisches National-
museum, Munich.

44 Romanesque art. *Altarpiece*. Salerno Cathedral.

witnesses to a certain intellectual and moral situation, and are able to throw light on the secret relationship between reality and representation, the factor that is probably most revealing of this new spirit is the evident necessity to enclose the upsurge of ardent Romanesque imagination within the logic of a lucid mental relationship between man and the world. There was a revival of faith in law, canons and measures; architecture became a strict kind of theorem and a kind of body stripped bare down to its muscles and nerves in a kind of mechanical perfection. Similarly sculpture fought for the 'emancipation of matter from weight'. Art of every kind tended towards a total work as the faithful image of the conception of the world that was current in this period of the Middle Ages, a world that was grandiosely ordered and enclosed. It was an art that was situated in the precise reality of everyday life, as a contribution to the increase of man's power, which to an increasing extent was seen to be part of this world. There was a new fashion for subtle intellectual creations, founded on dogmatic, logical, structures as strong and nervous as those of cathedrals. Intellectualism, the always present

limit, succeeded in the best cases in bringing about a balance between the spiritual experience of the ascetics and the new sentiment of earthly life. Despite all ethnic differences, which appeared at their strongest in languages and literatures, cultures and the figurative language of art tended towards an essential unity, despite local influences.

The minor arts were particularly fertile forms of expression for these ideas on life. People leading refined and pleasant lives could not fail to appreciate beautiful objects, precious materials and anything that conferred prestige and decoration on the owners, especially anything exotic of fantastic inspiration. Ivory had all the qualities necessary to satisfy such demands for it was a mysterious, almost enchanted, material that revealed unexpected iridescences as light played upon it. It was never static and immobile, and it seemed like a living substance offered to the light in an endeavour to capture its every nuance. These intrinsic qualities of ivory, together with its durability, gave it a luxurious, noble, and dignified quality. It was also esteemed because of its high cost and by the fact that it had to be brought from far-away exotic

countries like Africa and India, or from the fabulous seas of the north where Vikings hunted walrus for their ivory tusks.

In the Gothic period, ivory continued to enjoy great popularity. From the 12th to the 15th century, ivory work was a secularised and international European art. It became a court art, and carried motifs (knights, lovers, etc.) inspired by the life and literature of the court. A large number of ivory objects were made for profane use in 12th- and 13th-century England: chess pieces, hunting horns (still inspired by Arab-Sicilian models), jewel cases, writing tablets, musical instruments, saddles and horse furnishings, knife and dagger handles, chalices, combs, brooches and mirror cases. Besides their aesthetic value, such objects throw light on the upper reaches of Medieval society, telling us something about the tastes and aspirations of the nobles, the higher clergy and the rich mercantile middle class.

Paris was the great European centre of secular ivory art until the 13th century, when Italian work began to be popular all over Europe; by the end of the century the Venetian workshop of the Embriachi was

successfully competing with its French rivals. The objects made were essentially luxury articles in which ivory was used in combination with precious metals; the refined, courtly spirit of the scenes depicted were in harmony with the decorative fantasy of the style.

However, from an aesthetic point of view the most important works were still those made for devotional use, in a style resembling that of Gothic sculpture: statuettes of the Madonna and Child, diptychs and triptychs with scenes from the life of Christ, and so on. Madonnas were shown standing or seated, and though they were sometimes rendered in a Romanesque style, they expressed a quite different sense of reality. They became far more human in expression and – something new in Christian iconography – were sometimes represented giving the breast to the Child. Until the 13th century, ivory Madonnas kept the attitudes and characteristics of the earlier Virgins in Majesty; but in time they lost their monumental quality, and their forms were gracefully modelled, with finely balanced light and shade effects, in accordance with the taste of the time. Figures became soft and flowing, draperies fell freely or floated around the body to create smiling,

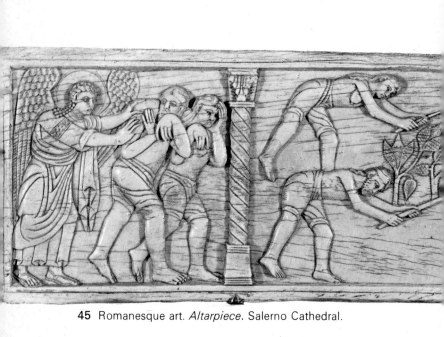

45 Romanesque art. *Altarpiece*. Salerno Cathedral.

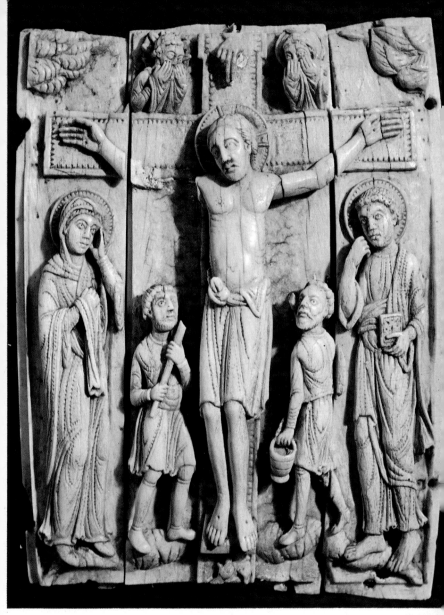

46 Romanesque art. *Crucifixion*. Schnütgen Museum, Cologne.

45 Romanesque art. *Altarpiece*. Salerno Cathedral. Like the previous example, this panel, which illustrates the expulsion of Adam and Eve from Paradise and the first human toil, shows the emergence of a new realistic tendency.

46 Romanesque art. *Crucifixion*. Schnütgen Museum, Cologne. An example of 12th-century German Romanesque art. The new spirit of European art stood in opposition to the formalism of Byzantine and Barbarian art, exhibiting a simple sense of humanity and greater interest in the things of this world. The most notable characteristic of this *Crucifixion* is that Christ is presented as a man.

47 Romanesque art. *Cover of the evangelistary of St Gilian*. University Library, Würzburg. The work reproduced features the decapitation of St Gilian and his relatives (*c.* 1090). The composition shows a sense of space, life and movement that was completely absent a century earlier.

47 Romanesque art. *Cover of the evangelistary of St Gilian*. University Library, Würzburg.

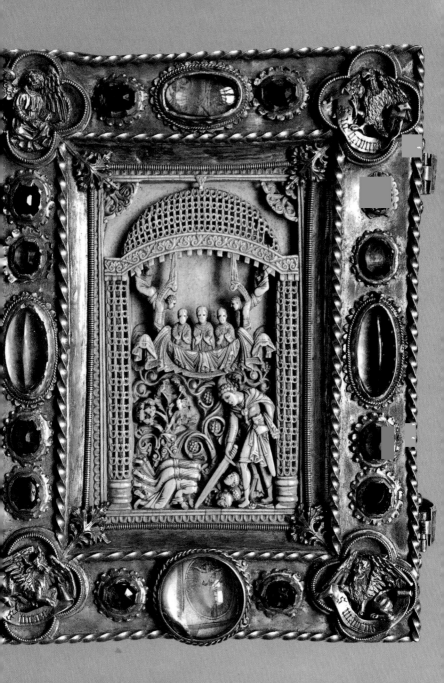

demure images. The 14th-century *Madonna* in Dijon Museum demonstrates the extent to which these figures had become humanised, and it should be compared with another splendid example of Gothic Classicism, the *Ste Chapelle Virgin* in the Louvre, or the *Coronation of the Virgin,* also in the Louvre, which is justly considered to be the masterpiece of 13th-century ivory art.

Even diptychs and triptychs, which had been designed with almost architectural precision in the 14th century, lost some of their intense religious force. Between the middle of the 14th and the beginning of the 15th century the transcendent ideals which had once dominated the whole of Western society began to decline in life as in art. Secular culture became increasingly refined and sophisticated; kings and nobles, once invariably illiterate, were sometimes themselves artists and poets, and became patrons who made their courts the intellectual and artistic centres of Europe.

Ivory objects were essential items in every court, castle and rich bourgeois household; but the themes employed in their decoration became increasingly

standardised even as they became more refined. Artists too often contented themselves with such standard decorative ideas as pairs of lovers transfixed by Cupid's arrows, riding together in a forest, or playing chess with their heads covered with garlands of flowers – all an accepted part of the repertory of the 'courts of love'. (Certain religious symbols and allusions also appeared, for although courtly art was worldly, the frontier separating it from sacred art was ill-defined, and the language, forms and themes of secular and religious art were still very similar).

These remarks apply not just to ivory works but to visual art as a whole. International Gothic was to reach an artistic impasse in every European country. Nothing new was created; artists used the same formulas over and over again, constantly refining them and displaying an ever-greater virtuosity which found an outlet only in an unreal decorative preciosity. This was true of even the finest works, for example the *Saint Laurence With the Grill*, a late 14th-century work from eastern France or the Rhine region, (Victoria and Albert Museum, London). Figures were portrayed with graceful gestures like those of ballet dancers;

they were elongated, and their fixed smiles seemed directed inwards. This late Gothic mannerism often involved formal complications, since artists strove for effects and were ready to sacrifice everything to outward charm. In Italy where other influences were at work the situation was somewhat better, though even here the standard of late Gothic ivory work was not high. The exception was the Embriachi family at Venice, who continued to work in a realistic vein, specialising in the production of marriage chests and mirror cases. Their works were generally free from Oriental influences as they were from the exhausted style of courtly art which might characterise them without ever dominating them. But this was an unusual exception, for even in Italy the standard of late Gothic ivory work was undistinguished. Most artists preferred to work with bronze, even for small works. It should also be noted that although Italian art never went to such 'intimate' and over-sentimental lengths as in the north, it never lost a certain Classical quality.

When life is regarded as a spectacle or a kind of pleasant, leisurely game, it is clear that artists will work

in a mannered, superficial style. A fluent, melodious, and unreal fairy-tale-like style, without the slightest hint of truth characterised art at the end of the Middle Ages and was to sap the creative faculty of late Gothic Europe, as it had already done to the Byzantine civilisation.

RENAISSANCE AND BAROQUE

The return of man to the centre of the universe was the revolutionary but inevitable point of arrival of the cycle which had started in the West in the Early Christian period. It was another time of change, but as with the period of crisis in the pagan world, it was one without any sudden jumps or breaks since history is a long, slow, intricate, flowing process of causes and effects, ferments and resistances, open and concealed.

In the Renaissance, man was considered for his individual worth and no longer as something within a context of dogma. As Henri Focilion wrote: 'Humanity did not renew itself by means of any massive purges: from its past, it has always retained certain intellectual and moral elements which might be of service for the

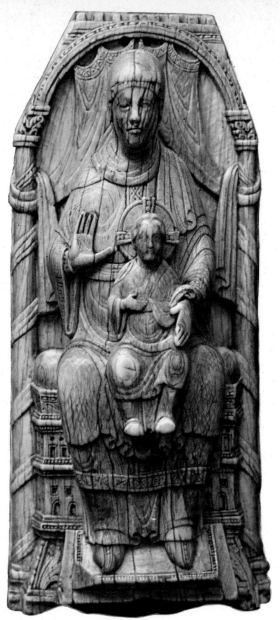

48 Romanesque art. *Madonna and Child Enthroned.*
Altertumsmuseum, Mainz.

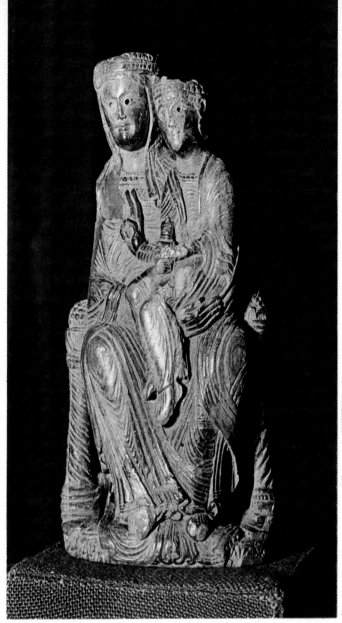

49 Romanesque art. *Madonna and Child*. Victoria and Albert Museum, London.

48 Romanesque art. *Madonna and Child Enthroned.* Altertumsmuseum, Mainz. This small, carefully executed sculpture was probably intended for domestic worship and has a typically Romanesque austerity and compactness. The enthroned figure, rigidly inscribed within an architectural scheme, was a frequent theme in 11th-century iconography.

49 Romanesque art. *Madonna and Child.* Victoria and Albert Museum, London. Ivory sculpture in Britain reached great heights in the Romanesque period. The sense of majesty and the austere rigidity of the figure give the work a profound inner serenity. A close relationship was developing between portal statuary in churches and small ivory sculptures for domestic worship.

50 Romanesque art. *Reliquary.* Herzog Anton Ulrich Museum, Brunswick. One of the most famous reliquaries, in which ivory was used together with gold and enamels. It represents the divine city of the Apocalypse and shows some surviving traces of Byzantine influence.

51 Romanesque art. *Chess pieces.* Museo Nazionale del Bargello, Florence. Ivory was used for a whole series of secular objects for the nobility and bourgeoisie. Chess pieces and other pieces for board games were made in quantities all over Europe, and were an excuse for displays of decorative virtuosity.

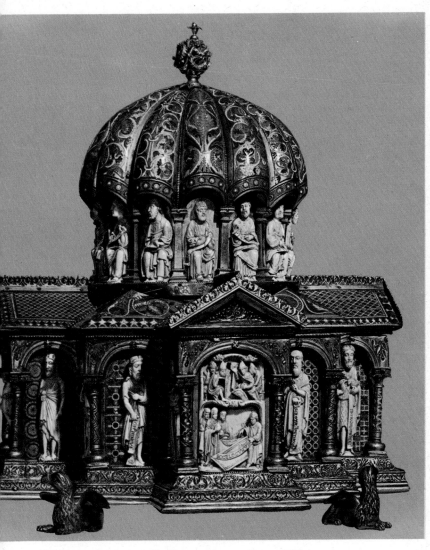

50 Romanesque art. *Reliquary*. Herzog Anton Ulrich
Museum, Brunswick.

51 Romanesque art. *Chess pieces*. Museo Nazionale del Bargello, Florence.

future. They might be characteristics that were obvious in one age and hidden in another but they always survived. On the other hand, forms did not leave merely ephemeral impressions in historical memory for even when they were no longer of topical interest they still survived with all the authority of concrete values and all their prestige despite variations in taste which are inherent in the grandeur and strength of an art form.' The aesthetic sense of the Renaissance was more than a desire to restore certain values which had been neglected or rejected for centuries; it certainly did not imply archaeological resurrection or a hasty, anti-historical return to the happy time of man's dominion over the world. It was the result of a slow and difficult process of adaptation and successive, gradual emancipations, which shaped an original picture of antiquity in the light of new beliefs, passions, and refusals, in a historicisation of everything that had occurred previously. Without the Gothic period, without the experiments of the Byzantine and Barbarian cultures, the Renaissance would only have been a pale and useless neo-Classical nostalgia for academic myths and formulas. The new cultural

climate signified the beginning of a vast and restless investigation of man and his history and we might also say that it was the result of adult awareness of all the tribulations, dissatisfactions and ruptures that had matured during the second millennium of Christianity.

It was a fact that the new age was aware of what it wanted and what it was living through, as was made obvious in all 14th-century historical thought. It was a different age in which antiquity, which had been buried for a while, re-emerged and flourished again, and the great lesson that had been lost with the downfall of the Roman Empire was learned anew. Comparisons with that remote culture produced a new canon for art, a new doctrine, and a new way of life, related to the idea of earthly perfection.

Life appeared as a blessing and supreme value in itself as Leonardo himself said, in his famous words: 'To the ambitious, who are not content with the blessing of life nor with the beauty of the world, it is given by way of penitence that they themselves spoil this life and are not able to see the utility and beauty of the world.' To sacred history and the history of the pagan world was now added the truly historic ideal

of everything that man had accomplished, since nothing that once had value could completely lose its vitality and meaning. Now that art proceeded with eyes open towards the recovery of this total reality that intellectual premises implied, it retraced the itinerary of consciousness, exchanging a condition of abandonment to supernatural faith for the bitter privilege of awareness. It is perhaps this which constitutes the most modern aspect of the revolution of the Renaissance: reality and nature were now regarded as living parts of a universe of which man was the measure.

The home of this earth-shaking event was Italy, and above all Florence, a city at the peak of its economic vitality. But as the Renaissance corresponded to a state of mind that was widespread in Europe, it soon overflowed the frontiers of Italy and made itself felt in Flanders, Germany, England, France and Spain.

In the minor arts, and ivory in particular, the relationship with architecture that had been so marked in the high Gothic period disappeared, and these arts again displayed affinities with painting and sculpture. Renaissance ivories are sometimes outstanding, for

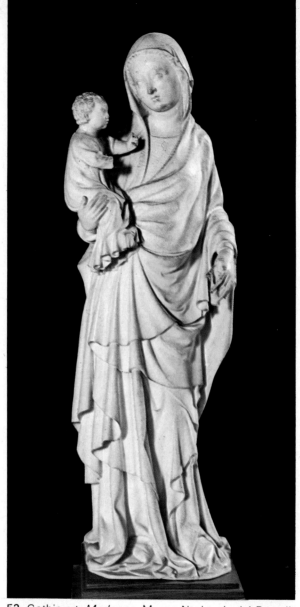
52 Gothic art. *Madonna*. Museo Nazionale del Bargello,
Florence.

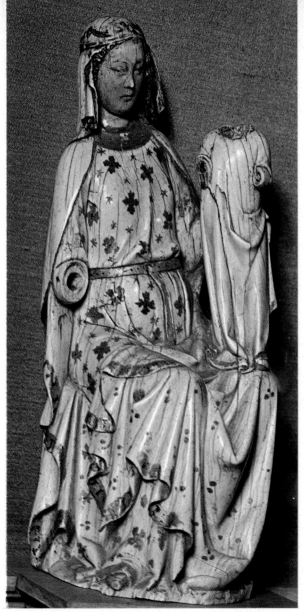

53 Gothic art. *Madonna and Child*. Musée de Cluny, Paris.

52 Gothic art. *Madonna*. Museo Nazionale del Bargello, Florence. In the Gothic period the process of humanisation of culture and art that had begun in Romanesque Europe suddenly accelerated; one of the most notable aspects of this occurred in the 14th century, when the theme of the Virgin and Child became identifiable with the idea of maternity.

53 Gothic art. *Madonna and Child*. Musée de Cluny, Paris. Another example of the humanisation of religious events: the sense of maternity is even more evident in this work. The agile, lively carving produces an elegant effect in harmony with the spirit of the Medieval courts.

54 Gothic art. *Crozier*. Victoria and Albert Museum, London. Croziers and *taus* were usually decorated in the Gothic period with bizarre forms and lively plant and animal themes.

55 Gothic art. *Ivory chalice*. Cathedral treasure, Milan. In the 14th century, French Gothic artists produced many objects, sacred and profane, in an essentially secular taste. The chalice reproduced was destined for liturgical use, but in form and style it is not very different from secular cups.

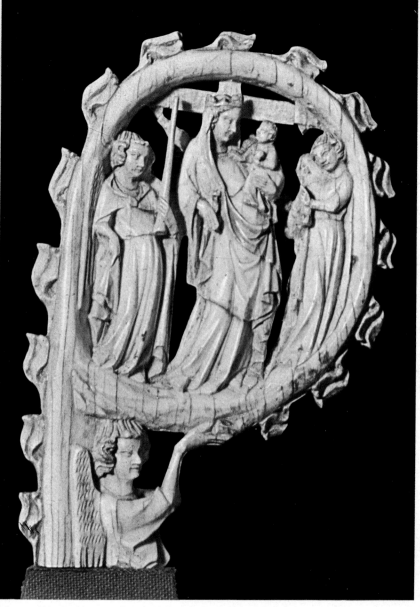

54 Gothic art. *Crozier*. Victoria and Albert Museum,
London.

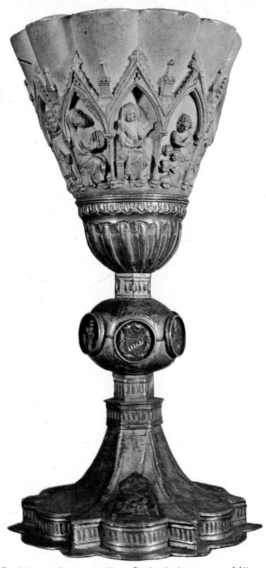

55. Gothic art. Ivory chalice. Cathedral treasure, Milan.

example *Virtue Overcoming Vice* (Plate 51), or the bas-relief of the Petrarchan *Triumphs*; but on the whole the Renaissance was an undistinguished period in the history of ivory carving, falling between the great flowering of the art in the Middle Ages and the more subtle flowering of the Baroque age. Moreover, the formal purity of the high Gothic was in violent contrast with the expressive and realistic experiments that now predominated. The irrational, fairy-tale like quality of the 14th century was obviously no longer in harmony with the rational, measured and three dimensional view of the world that now prevailed. Ivory carvers who were aware of the sudden change in the cultural climate tried as best as they could to adapt themselves satisfactorily to the new three-dimensional, realistic art; there was no great artist in ivory, and the great artists preferred to work in stone and bronze. Consequently it is risky to attribute ivories to such artists as Benedetto da Maiano, Giambologna or Cellini; in most cases, such works were copies of varying quality of their works or simply imitations in the manner of the masters. The statues and paintings that

furnished the most convenient models were unsuitable for reproduction in miniature and even the most successful ivory works suffered from the contradiction of a monumental composition weakened by an outmoded style.

Similarly the countless ivory statuettes of religious or mythological figures were all too often mere pretexts for excessive display of virtuosity and feeble complaisance in the handling of draperies and minute detail. In this process of imitation, nothing remained of the technical independence that the Middle Ages had so carefully respected and soon ivories could no longer be said to be imitations even when they had become direct copies.

In fact, first imitation and then direct copying of works carved in marble or cast in bronze became the main activity of the ivory carver. In Italy, marble or enamelled terracotta altarpieces were the works most frequently copied, as well as such works as the reliquary in Graz cathedral, Mantegna's *Triumphs*, and even Michelangelo's great works, the most famous example being the *Descent from the Cross* in Florence, taken directly from a drawing by Michelangelo. As well as

renouncing technical autonomy for the sake of passively imitating large-scale sculpture, Renaissance carvers further weakened their art by an excessive striving for virtuosity in the modelling, with ivory reliefs copying pictorial effects and even the perspectives and colour schemes of paintings. Never before had the art been so mechanically imitative.

Only when ivory carvers ceased to imitate works in the 'major' arts did their craft flourish again. The recovery began in the 16th century, when artists began to carve ivory medallions, and when the Italians invented an original and independent form of portraiture in ivory that was to be practised and developed all over Europe in the Baroque and the Rococo styles. Ivory was also used for the making of rosaries; devotional objects of Medieval content and typically Renaissance form, which became fashionable in Germany and Flanders. Each rosary bead consisted of two or more heads of finely carved ivory – usually skulls alternating with female heads as a kind of reminder of human mortality. A few dignified and beautiful specimens of these works may be seen in the Victoria and Albert Museum, London, and the

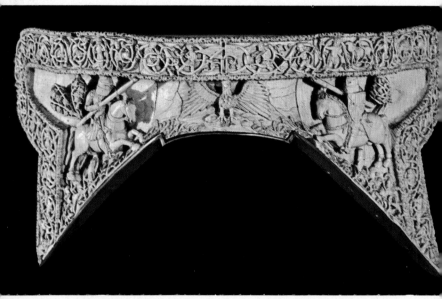

56 Gothic art. *Saddle bow*. Musée du Louvre, Paris.

57 Gothic art. *The Taking of Christ*. Fragment. Musée du Louvre, Paris.

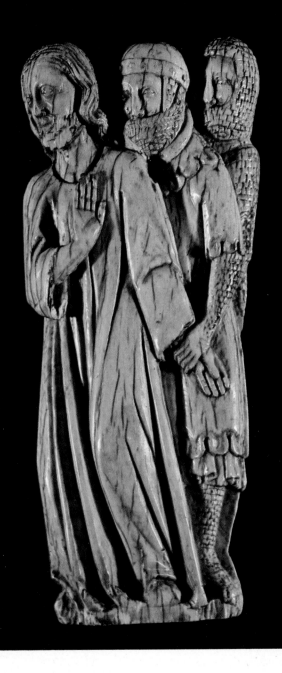

56 Gothic art. *Saddle bow*. Musée du Louvre, Paris. Probably of southern Italian provenance; a notable example of an object made for a courtly and splendid society. The ornamental motif, shaped like a cornice with two horsemen facing each other, displays a high degree of workmanship and a considerable artistic imagination. This object belonged to Frederick I, prince of Aragon and king of Sicily.

57 Gothic art. *The Taking of Christ.* Fragment. Musée du Louvre, Paris. French 13th-century art was rich in representations of various stages of the Passion. The work reproduced is notable for the impression of monumentality it gives despite its small size. The flow of lines, stressing the overall unity of the composition, is particularly beautiful.

58 Gothic art. *Harp with scenes of the Massacre of the Innocents.* Musée du Louvre, Paris. Another object displaying great technical and artistic skill; it was probably made in Burgundy in the 14th century and destined for the ducal court. One side depicts scenes from the *Massacre of the Innocents* and elegant, stylised floral motifs; the other shows the *Adoration of the Magi* and the *Nativity.*

59 Gothic art. *Side of a mirror case with scenes of the court of the god of Love.* Musée du Louvre, Paris. Another French work of the 14th century. Artistically it is rather conventional, displaying virtuosity rather than feeling; but it is particularly noteworthy for the extreme delicacy of a technique which has been taken to its limit.

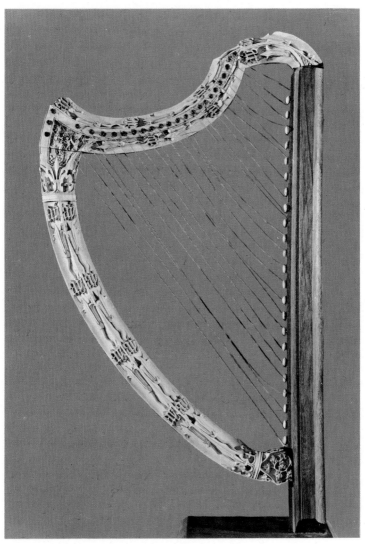

58 Gothic art. *Harp with scenes of the Massacre of the Innocents*. Musée du Louvre, Paris.

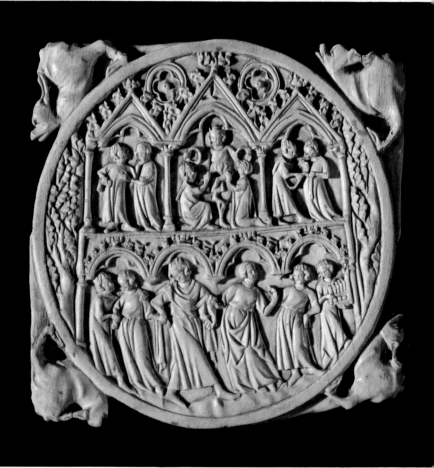

59 Gothic art. *Side of a mirror case with scenes of the court of the god of Love*. Musée du Louvre, Paris.

Louvre in Paris; they have been carved confidently, with great technical skill, and their forms are as precise as those of coral cameos.

The increasing secularisation of the art became even more marked. A whole series of articles, both old and new, were made to satisfy the demands of the aristocracy and bourgeoisie. Ornamental compositions sometimes revived certain traditional themes, such as fights with dragons and monsters, and vegetal and animal arabesques, but there were also mythological, courtly and hunting scenes that were Classical rather than Medieval in spirit. Examples of these tendencies are the sumptuous knife handles made in France under Italian influence, or the combs on which sacred and profane motifs are mingled—*Paris and the Three Graces* or *David and Bathsheba* enclosed within lavish borders of female nudes, etc. Widespread enthusiasm for Italian art, even when it was of indifferent quality, the increasing tendency to react against the Middle Ages and its rigid doctrines, and a more centralised monarchy, all led to profound changes in French culture and artistic production.

After flourishing for centuries, ivory carving rapidly

declined in France. Flemish craftsmen, on the other hand, made such popular articles as gunpowder flasks, decorated with the usual mythological and religious scenes, and, later, tobacco graters. (These had a great success in the Baroque period, and consisted of a small metal rasp enclosed between two ivory valves.) But even the ivories of the Flemish school were characterised by an artificial striving for virtuoso effects. Ivory imitations of the most highly prized works of painting and sculpture were soon being made everywhere: German artists even made ivory copies of Dürer's engravings. In the 15th and 16th centuries, artists continued to make a great quantity of small religious statues, which are far easier to attribute to a particular country than to any single artist. Italy, France, Flanders and Spain flooded the market with such objects, all similar in style.

European ivory art in the Renaissance was characterised by this new kind of artificial mannerism which soon lost all vitality and degenerated into a kind of technical aestheticism, with the 'formal vocation' of ivory, consisting of its graphic purity of form, delicacy of relief, and the possibilities it offered craftsmen, in

60 Gothic art. *Sword handle*. Victoria and Albert Museum, London.

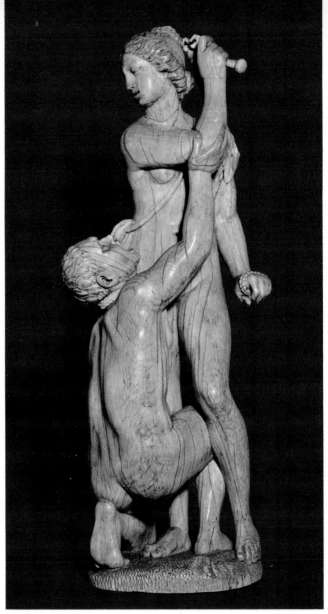

61 Renaissance art. *Virtue Overcoming Vice*. Musée du Cluny, Paris.

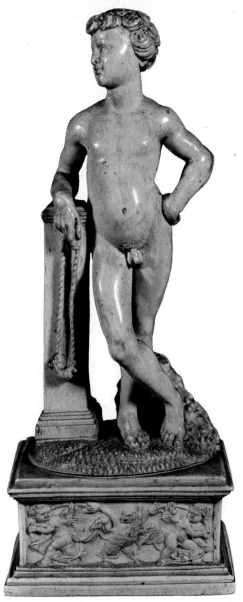

62 Renaissance art. *David*. Museo Nazionale del Bargello, Florence.

60 Gothic art. *Sword handle.* Victoria and Albert Museum, London. This French sword handle, dating from *c.* 1350, is a typical piece of decorative extravagance, produced for a sophisticated court society. There is already a certain preciosity of line indicative of creative exhaustion.

61 Renaissance art. *Virtue Overcoming Vice.* Musée du Cluny, Paris. The moralistic subject of this beautiful statuette is clearly nothing but a pretext for a free, forceful anatomical study of nude bodies. The Renaissance saw the beginnings of decadence in ivory art, since carvers began the passive imitation of large sculptures.

62 Renaissance art. *David.* Museo Nazionale del Bargello, Florence. An Italian work of the late 16th century in which technical and imitative virtuosity produced all the effects of which monumental sculptors were capable. The independent technique of ivory art, which had survived for centuries, was abandoned, and ivory was freely combined with such materials as marble or bronze.

63 Renaissance art. *Powder horn.* Galleria Estense, Modena. The discovery and use of gunpowder led to the creation of a new ivory object which was both utilitarian and aesthetically pleasing. Such objects were made all over Europe, but especially in Germany, where the surfaces of powder horns and flasks were decorated with the usual mythological or religious subjects. The example reproduced is of German workmanship and dates from the second half of the 16th century.

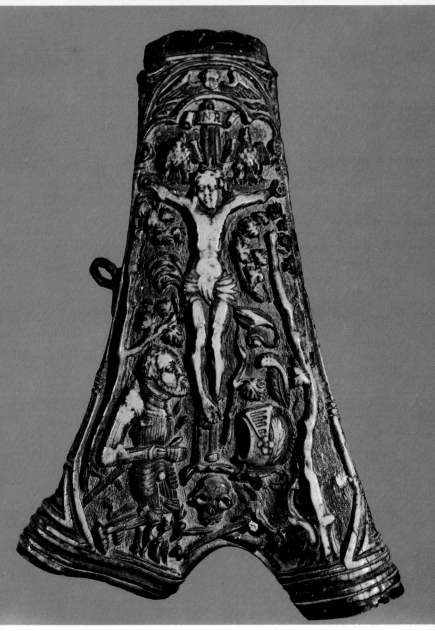

63 Renaissance art. *Powder horn*. Galleria Estense, Modena.

brutal contrast with the spirit of an age when stress was laid on the integral representation of the human form. For this purpose, bronze and stone sufficed for they could be used in large and small scale works and lent themselves to the softest modelling and most graceful linear composition. Ivory art needed a new impetus for it to escape from its stagnant state. There had to be genuine, vigorous assimilation rather than mere imitation of large scale sculpture; images, style and concepts all had to be digested thoroughly. Above all, it was necessary for any artist of real talent to have a sensitive appreciation of his material, to be aware of its instrinsic qualities, organic structure, limits, and dimensions. By the end of the 16th century, these conditions appeared to be all present – at least in Italy. There, the extreme forms of the perfect 'renaissance', the view of the Classical heritage as something related to the living world of nature rather than as the province of the scholar, the reaction against the precious stylistic affectations and useless artificiality of a manner that had had its day, the realistic revolution in painting made by Caravaggio and the three Carracci and even earlier by the Ferraresi, who brought

a 'visualisation of the occult' into contact with the problems of the Renaissance and the renewed power of the Catholic church which had triumphed over Protestant heresies in the Counter-Reformation, all produced a vital condition of cultural ferment in which the fantastic imagination of Gian Lorenzo Bernini could give itself free rein. The Renaissance had now exhausted its original driving force which had been an adhesion to the natural world in the spirit of antiquity. Henceforth, the lessons of the Classical past no longer seemed necessary and preference was given to direct observation, experiment, and an awareness of truth in place of the memory of antiquity. At the same time the Papal and absolute powers were growing and the discovery of man and the universe that had been made in the Renaissance was now seen in the light of codified doctrines. Political and ideological repression naturally led to a disguise of ideas and a mystification of liberty in the forms of the imagination; the laws of metaphor, evasion and the marvellous now triumphed. The situation was difficult and even risky but an artist with a bold imagination could still create forms of freely inspired beauty which were unaffected by the

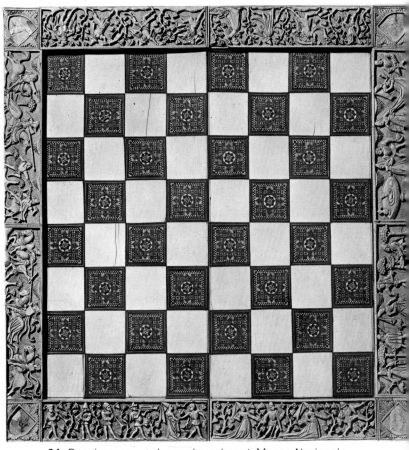

64 Renaissance art. *Ivory chess-board*. Museo Nazionale
del Bargello, Florence.

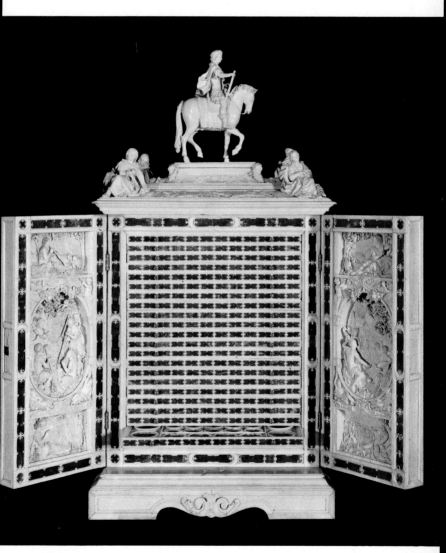

65 Baroque art. *Coin case.* By Christoph Angermayr.
Bayerisches Nationalmuseum, Munich.

64 Renaissance art. *Ivory chess-board.* Museo Nazionale del Bargello, Florence. It was in fairly sober objects for use, such as this 15th-century French chess-board, that Renaissance ivory art was at its most dignified. The return to a simple Classicism makes the object very pleasing.

65 Baroque art. *Coin case.* By Christoph Angermayr. Bayerisches Nationalmuseum, Munich. Perhaps Angermayr's masterpiece. The exuberant ornamentation, derived from Italian Renaissance work, does not interfere with the clarity of the overall composition. Angermayr made this case between 1618 and 1624, in collaboration with Peter Candid, for the wife of the Elector Frederick IV.

66 Baroque art. *St Sebastian.* Attributed to Georg Petel. Bayerisches Nationalmuseum, Munich. The talented sculptor Petel was influenced by the art of Van Dyck and Rubens, though he remained faithful to certain strong local traditions. In this *St Sebastian* the language of Baroque art has found its own independent expression.

67 Baroque art. *Venus.* By Ignaz Elhafen. Bayerisches Nationalmuseum, Munich. A nostalgic ideal of grace seems to pervade this languid statuette, which represents a marginal but quite vigorous trend in 18th-century German sculpture, in opposition to the expressionist tendencies of such contemporaries as Günther or Permoser.

66 Baroque art. *St. Sebastian.* Attributed to Georg Petel. Bayerisches Nationalmuseum, Munich.

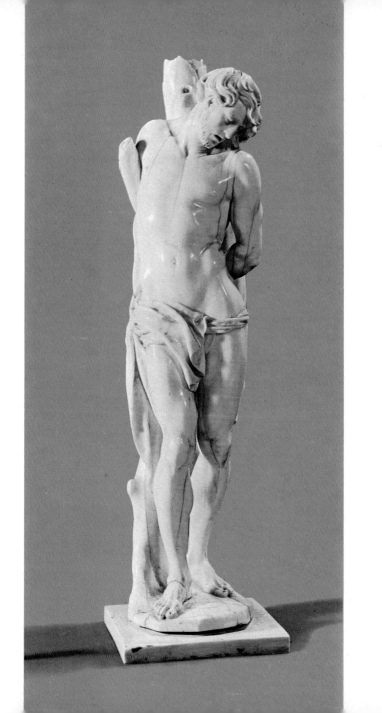

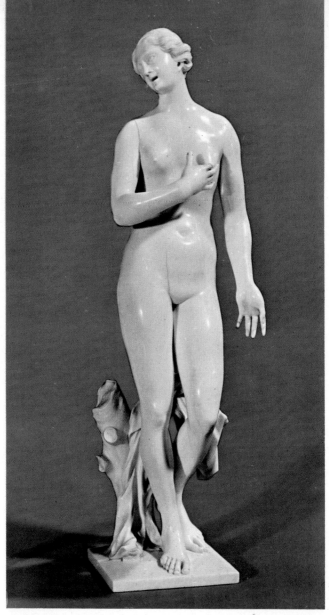

67 Baroque art. *Venus*. By Ignaz Elhafen. Bayerisches
Nationalmuseum, Munich.

conflict between authority and reason and authority and freedom. The idea of the Baroque has been a subject of controversy for historians and critics, with some, like d'Ors, stating that it is a category or quality to be found in every culture. The fact remains that the Baroque was produced by an essentially contradictory situation, an age that was full of doubts, worries and antitheses, but nonetheless full of vitality. Different kinds of Baroque may be recognised: there was a hollow Baroque, an active Baroque, a positive and a negative Baroque and they were all the expressions of the complexes that were contained and compressed by an intellect that was strongly rational, yet full of sensuality and fantasy. Whereas Classicism took man as its measure, the universe now tended to become the measure of the Baroque. Art descended from its immobile metaphysical heights, the inner drama of the work of art freed itself and exploded into a lively rhythm of chiaroscuro light and colour effects which were all so many expressions of life. As usual, the new art was an old form in a new guise. Baroque culture meant perfect attention to nature and anatomy, as the laws of perspective and spatial stimulation, and a

complete control of matter. The object was no longer caught in its essence but in its phenomenological state of becoming, in a deformed Hellenistic conception of the world in the sense of the imaginative, the grandiose, the infinite, and a passionate naturalism. The result for art was that the relationship with things, their measure and their mystery was profoundly changed.

Ivory ceased to be an imitative art only when the Renaissance style gave way to the Baroque, when even sculptors of the first order worked in ivory. This happened everywhere in Europe, but first of all in Italy, where Alessandro Algardi worked in ivory in a Classical style tempered by his naturalistic vision. Other ivories were made by Guglielmo della Porta, Girolamo Campagna (one of whose most important works is the *Christ with Angels* on the altar of S. Giuliano, Venice), Antonio Leoni and Becenigo di Asti. All were sculptors, known for large-scale works, who approached working in ivory with talent and enthusiasm, creating statuettes and other objects that strongly influenced other European artists.

Active German artists included Balthasar Permoser, Christoph Angermayr, Andreas Faistenberger, Ignaz

Elhafen and Matthias Rauchmiller, some of whom had served long apprenticeships in Italy. Because of them, the finest ivory art of the 17th and 18th centuries was mainly German; Germany regained the supremacy that she had enjoyed during the Carolingian, Ottonian and Romanesque periods. A decisive impetus was given to the art by rulers who had a taste for ivories, for example George William, the Elector of Brandenberg, John William of the Palatinate, August the Strong of Saxony, and the Holy Roman Emperor Rudolph II, himself a pupil of the Nuremberg sculptor Peter Zick. The most famous artists of the age came to the Imperial court from abroad; those who worked in ivory included the Fleming van Bossuit, the Dutchman Zeller, and the Italian Leoni. The major centres of ivory art were at Dresden and in Bavaria, where whole dynasties of highly-skilled carvers came to prominence, transmitting the art from father to son: the Krüger family, the Kellers, the Zicks, the Lückes.

The works they produced included altar statues, portraits of sovereigns and nobles, small allegorical statues in the style of garden statuary, beer mugs,

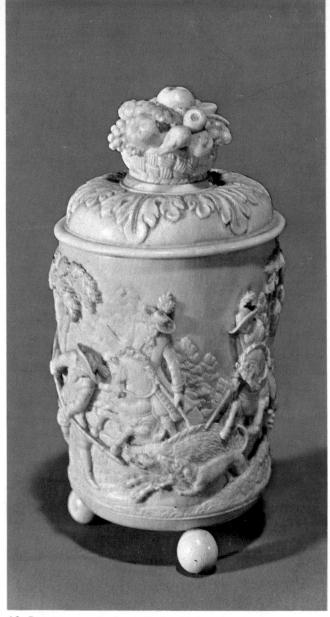

68 Baroque art. *Perfume flask with hunting scenes.*
Bayerisches Nationalmuseum, Munich.

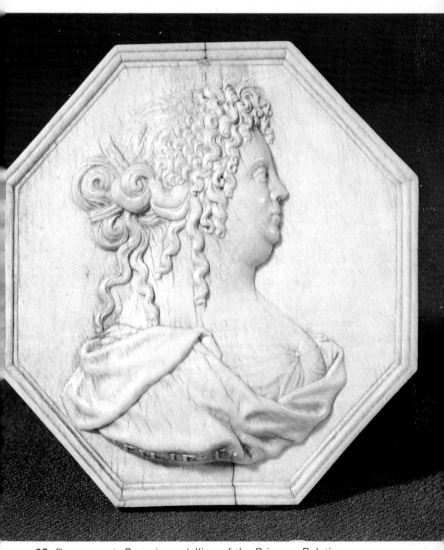

69 Baroque art. *Portrait-medallion of the Princess Palatine.*
Musée de Dieppe, Dieppe.

68 Baroque art. *Perfume flask with hunting scenes.* Bayerisches Nationalmuseum, Munich. The sumptuous and rather showy decoration crowds the surface of the flask with images and light and shade effects.

69 Baroque art. *Portrait-medallion of the Princess Palatine.* Musée de Dieppe. This work is by Filie, a member of the French school of portraitists working in Dieppe in the 17th century. In this period the city became an important European centre of ivory art, and its artists and craftsmen made every sort of object from statuettes to fans, tobacco boxes and fine filigree shuttles.

70 Baroque art. *Lid of a case.* Musée de Dieppe, Dieppe. Another object made in the famous Dieppe workshops, adorned with a neat and accurate decoration in Louis XV style.

71 Baroque art. *The Seasons.* By Antoine Belleteste. Musée de Dieppe, Dieppe. In a style similar to that of the statuary of Versailles. Belleteste made some of the most important works of the Dieppe school. He was a skilled worker who avoided academic sterility despite the frequency of commissions for allegorical figures. He belonged to a family of ivory carvers who had practised the craft for generations.

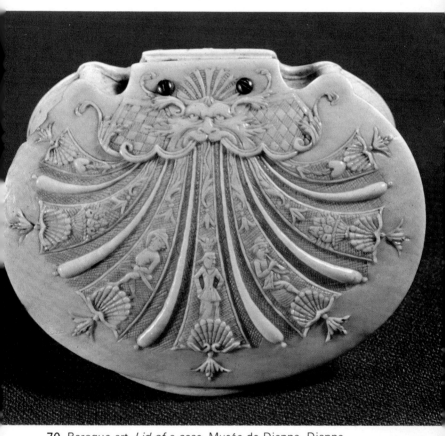

70 Baroque art. *Lid of a case*. Musée de Dieppe, Dieppe.

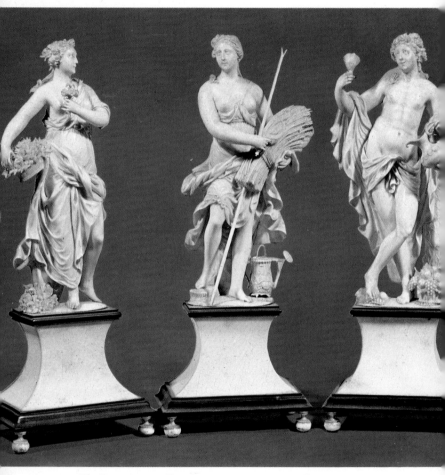

71 Baroque art. *The Seasons*. By Antoine Belleteste. Musée de Dieppe, Dieppe.

chalices, plates and clocks. The suitability of ivory for displays of technical virtuosity and fantasy aroused great enthusiasm. One of the most extraordinary and extravagant examples of this art was the coin cabinet made between 1618 and 1624 by Christoph Angermayr, a piece of furniture almost a yard high, covered with decorations in the style of the Italian Renaissance and crowned by the figure of the Emperor on horseback dominating his subject peoples (plate 65). Later, artists produced numerous bizarre objects, often of remotely Chinese inspiration: an ivory model of a foetus in the womb, Siamese twins, a bearded girl.

French ivory carvers were of almost equal distinction. Crucifixes and statuettes of the Virgin and saints were the main religious objects produced; among secular objects were mythological bas-reliefs to decorate furniture, cases and boxes, small sculptures (mainly miniature reproductions of large allegorical marble statues), medallion portraits and busts in the round, and various useful objects such as tobacco jars, back-scratchers and fans.

There was a whole school of French ivory artists from Guillermin de Lyon to Gérard van Opstal, in

origin a Belgian. Van Opstal also sculpted in marble, but his sensual Baroque taste for fantasy and the picturesque found an ideal outlet in ivories. He carved mythological and Arcadian scenes, children and animals, in pieces that all displayed his mastery of modelling.

Two other French sculptors who made important ivory portraits were Jean Cavalier and David Le Marchand. Cavalier worked in London, Bavaria, Vienna and Stockholm as well as France. He was a great specialist in medallions, and his services were in great demand in all the European courts; no less than 170 portraits have been attributed to him. He treated his subjects with panache and refinement, composing finely balanced forms that belonged to the great tradition of French 17th-century portraiture. Le Marchand had only a limited success; he worked in Dieppe, which was a flourishing centre of ivory carving. Apart from medallions in the style of the time, he made a fine series of busts, including those of Newton (1718, British Museum, London) and Anne Churchill, Countess of Sunderland. Also from Dieppe came Jean Mauger, Jean Antoine Belleteste, and the

Rosset family; Rosset *père* owed much of his fame to his portraits of Voltaire, Montesquieu, Rousseau and D'Alembert – the leading spirits of the Age of Reason.

Important works were also being made by Flemish artists such as François Duquesnoy and Lucas Faidherbe, a pupil of Rubens who translated many of his master's compositions into ivory. Apart from such ambitious works, which were soon influenced by the Rococo style, and were sometimes of great beauty, a multitude of more humble but useful articles were produced. It is precisely in these humble objects that the tradition of the anonymous ivory carvers of the Middle Ages survives – a tradition which avoided showy virtuosity and made no pretence of rivalling the major arts; these craftsmen were content to develop their technical skill and achieve unobtrusive effects through the intrinsic beauty of the materials.

In the late 18th century, the art of ivory carving effectively came to an end. Other materials, other fashions, other problems, and other social conditions made ivory carving a commercial activity, devoted to the reproduction, in the greatest possible number, of traditional objects.

LIST OF ILLUSTRATIONS Page